IMAGES
of America

BOSTON

IN MOTION

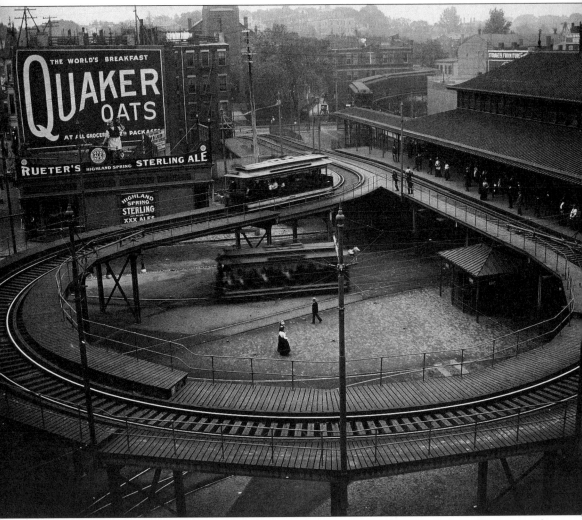

The Dudley Street Station was photographed on September 17, 1901, with trolley cars and an elevated train entering the station, which within a decade would become one of the busiest terminals in the United States.

Cover: Boston opened America's first subway on September 1, 1897, and here we see a trolley car near the Park Street Station in August 1897 on an instruction trip. In 1901 a large section of this trolley subway was adapted for use by elevated trains.

IMAGES
of America

BOSTON
IN MOTION

Frank Cheney and Anthony M. Sammarco

ARCADIA

Published by Arcadia Publishing,
an imprint of Tempus Publishing, Inc.
2 Cumberland Street
Charleston, SC 29401

Printed in Great Britain.

Library of Congress Catalog Card Number: 99-60793

For all general information contact Arcadia Publishing at:
Telephone 843-853-2070
Fax 843-853-0044
E-Mail edit@arcadiaimages.com

For customer service and orders:
Toll-Free 1-888-313-BOOK

Visit us on the internet at http://www.arcadiaimages.com

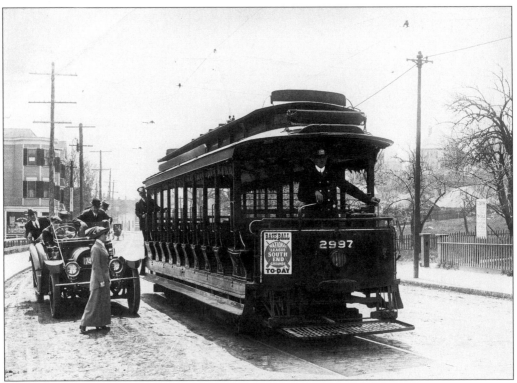

A woman awaits an open car trolley in Jamaica Plain c. 1917. These open cars were
phased out of service in late 1919 because they required a two-man crew. There was an
increase in accidents to passengers boarding and alighting by automobiles. The Eastern
Massachusetts Street Railway would continue limited use of open cars in Revere, Lowell, and
Brockton until 1929.

CONTENTS

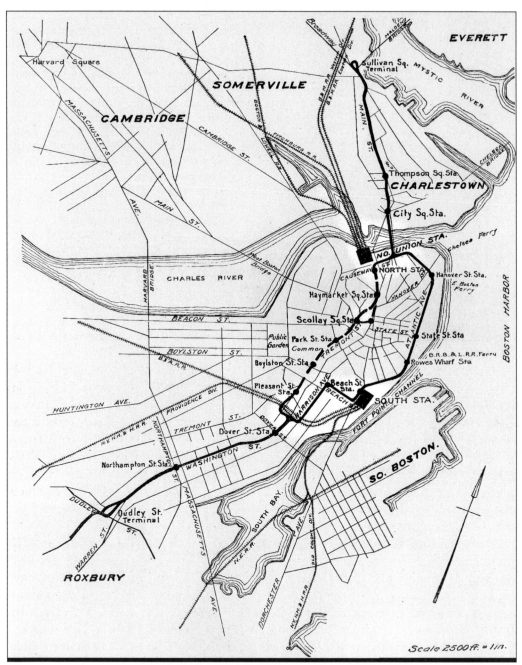

The territory covered by the Boston Elevated Railway is marked by a solid black line that runs from the Dudley Street Terminal to the Sullivan Square Terminal, with the Atlantic Avenue Branch from Harrison Avenue to North Station. The train lines, radiating from Boston, extended to the north, west, and south of the city.

INTRODUCTION

Since Boston is among America's oldest cities, it is natural that its transit system has a long and colorful history, stretching back several hundred years.

The first public transit in Boston, and in fact in North America, dates back to November 6, 1630, when the Court of Assistants of the Massachusetts Bay Colony established a franchise for the operation of a ferry service between Boston, Charlestown, and Chelsea (then known as Winnissimmet). The first holder of this franchise was William Converse, who began operation of the Winnissimmet Ferry (as it became known) in June 1631. In October of 1637, the legislature awarded the franchise to Harvard College "who may assign the franchise as they see fit;" the revenue from the ferry was to be used for the support of the college. This arrangement continued until early 1831, when Harvard decided to sell the franchise because it had other sources of income.

A newly formed company, the Winnissimmet Ferry Company, who had immediately placed new steam ferry boats in service to replace the outmoded sailing vessels, purchased the franchise. In 1857 the ferry company established the Winnissimmet Horse Railway Company to operate horse cars in Chelsea and Boston. The cars were carried across the harbor on the company's ferry boats, along with horse cars of the Lynn & Boston Railroad Company, which was also controlled by the ferry company. The Lynn & Boston Line would later evolve into the big Eastern Massachusetts Street Railway Company that eventually merged into the modern day MBTA system.

Additional ferry lines began operation across the harbor connecting downtown Boston with East Boston—the East Boston or South Ferry in 1832, and the People's Ferry or North Ferry in 1853, which was noted for its white boats. These two lines came under city ownership in 1870 and discontinued operation in 1952 and 1933 respectively, while the original Winnissimmet Line ceased operation in January 1917. A fourth ferry line, owned by the Boston, Revere Beach, & Lynn Railroad, primarily served to carry the railroad's passengers from the East Boston Terminal to Atlantic

Avenue in Boston, and was operated by the railroad from 1878 to 1940.

Looking now at land-based transit, the mid-18th century saw long distance mail and passenger coaches in operation, connecting Boston with Worcester, Salem, Plymouth, Providence, RI, and Portsmouth, NH. Originally only running once or twice a week, service increased as the demand required.

By the early 19th century, it had become apparent that a market existed for local or short distance transportation. In 1826 the first local stages or omnibuses began operation on an hourly schedule—one line linking Harvard Square with Scollay Square, with the other running from the Roxbury Town House to the Boylston Market in downtown Boston. Such was the popularity of these two lines that omnibuses were soon running as frequently as every 10 minutes.

By the early 1830s, 19 local omnibus lines were in operation providing frequent service from downtown Boston to all nearby towns. The introduction of horse cars in 1856 generally eliminated most of the omnibus lines, which eagerly sold out to the new horse railways. The last independent omnibus line, known as the Citizens Line, was operated by Jacob Hathorne and connected Dudley Square with Sullivan Square and sold out to the West End Street Railway in 1889, after being in operation for 40 years.

The next form of surface transit to appear on the Boston scene was the steam railroad. The first steam locomotive in Boston arrived by ship from England early in April 1834. The locomotive *Meteor* was unloaded at Long Wharf and hauled through the streets by a large team of horses to the new depot of the Boston & Worcester Railroad Company, located at the corner of Washington and Corning Streets. The Worcester Line opened for traffic as far as Newton on April 17, 1834, and by 1847 railway lines radiated outward from Boston in all directions and had begun providing local commuter service. These lines enjoyed heavy patronage up through the late 1920s, when a combination of heavy automobile competition and railroad financial mismanagement lead to increasing cutbacks in both maintenance and service on Boston's commuter rail system. The still heavily patronized Old Colony Division was shut down in July 1959. By the late 1960s, the state-operated Massachusetts Bay Transit Authority (MBTA), which had been created in July of 1964 to operate all local transit lines, including the former Boston Elevated/MTA and Eastern Massachusetts Street Railway systems, was forced to take over the now decrepit commuter rail operations of the bankrupt railroads. Between the mid-1970s and 1995, the MBTA completely refurbished and modernized the entire commuter rail system and re-opened two of the three Old Colony Rail Lines in September 1997, with the third Old Colony route due to reopen in 2000.

Moving back to the early 1850s, many Bostonians had come to look upon the competing omnibus lines serving the city with growing distaste. Viewed as dirty, smelly, overcrowded, and rough riding, as well as the subject of almost daily newspaper editorials, the time seemed ripe for some sort of major transit improvement. In the spring of 1853 a small group of local businessmen met at the Exchange Coffee House in downtown Boston. They organized the Metropolitan Railroad Company to operate a horse car line between the Roxbury Town House and the Boylston Market in Boston. Shortly thereafter, a second horse railway, the Cambridge Railroad, was organized to

operate horse cars between Harvard Square in Cambridge and Bowdoin Square in Boston. A race ensued between the two companies to become Boston's first horse railway and was won by the Cambridge company, who obtained second-hand horse cars from Brooklyn, NY, and began operation on March 26, 1856, while the Metropolitan opened its line using new cars on September 17 of that same year.

Steam-powered streetcars were operated on four routes in the Boston area from May 1865 to November 1867 but were not considered successful. By early 1885, the cars of seven horse railway companies were jostling for space on Boston's narrow, curving downtown streets. In November of 1887 businessman and real estate developer Henry M. Whitney consolidated all of Boston's horse railways, except the Lynn & Boston Railroad, into one huge system known as the West End Street Railway. The astute Whitney quickly decided that his new railway system, with its 1,700 horse cars and 7,780 horses to pull them, should seek a mechanical means of propulsion. This became Whitney's next order of business.

Early in 1888 trials with several battery-powered cars proved unsuccessful, so Whitney decided to install a cable car system in Boston, such as those operating successfully in New York, San Francisco, Chicago, and Kansas City. With the design and engineering for the cable car system underway, Whitney came across the Jamaica Avenue Electric Trolley Line while on a business trip to Brooklyn, NY. Whitney inspected and rode the line and decided that while poorly built, it functioned efficiently and economically. He then decided to inspect a larger and better-built system installed in Richmond, VA, by a former naval engineer Frank J. Sprague. Whitney invited Sprague to install a similar system between Boston and Brookline, while the Thomson-Houston Company of Lynn, MA, built a second electric line linking Harvard Square with Bowdoin Square in Boston.

The Beacon Street route to Brookline opened on January 5, 1889, and is today part of Boston's modern Green Line system. The Cambridge Line opened on February 16, 1889, and by the fall of 1895, virtually the entire Boston streetcar system was electrified. The last horse car line, a short route on Marlborough Street in the Back Bay, closed on December 24, 1900.

The installation of electric trolleys was a catalyst for an involved series of mergers that resulted in two huge transit systems, the Boston Elevated Railway/MTA and the Eastern Massachusetts Street Railway, which dominated transit in Eastern Massachusetts. These two firms formed the basis for the present MBTA.

Not only did Boston open America's first subway, the Tremont Street section of the present Green Line, on September 1, 1897, but for over 50 years it was one of only four North American cities to have a comprehensive subway-elevated system (the other three being New York, Philadelphia, and Chicago). Possession of such a comprehensive transit and commuter rail system over the years has enabled downtown Boston to continue to thrive and develop as a vibrant commercial, educational, and medical-science center.

The first elevated lines, connecting Dudley Street in Roxbury with Sullivan Square in Charlestown, opened on June 10, 1901, followed by the line on Atlantic Avenue on August 22, 1901, which linked the North and South Railroad Terminals with the ferry

and steamship docks along Boston's waterfront. The under harbor tunnel from Scollay Square to Maverick Square in East Boston opened on December 20, 1904, and after several extensions in the 1950s, is now Boston's Blue Line.

On March 23, 1912, the Cambridge Subway opened connecting Harvard Square with Park Street in downtown Boston. The Cambridge Subway, now part of the Red Line system, is unique in that it is one of only three subway lines in the United States to be built entirely with private funds. The other two are the Market Street Subway in Philadelphia and the Hudson and Manhattan Tubes in New York City.

Motor buses appeared in the Boston area in 1918, when the Bay State Street Railway placed buses on four short routes in the suburbs as a cost-cutting measure. On February 22, 1922, the Boston Elevated Railway introduced buses on the North Beacon Street Line in Brighton. Within ten years the motor bus became an important element in the Boston area transit system.

Another type of transit vehicle, the electric trolley bus, was placed on the route running from Lechmere Square to Harvard Square in Cambridge on April 11, 1936, and on a second line from Harvard Square to Huron Avenue on April 2, 1938. Within a few years these quiet, speedy, fume-free, and economical vehicles had replaced trolley cars and motor buses on 41 routes all over Metropolitan Boston. Unwise policy decisions in 1961 and 1962 resulted in the replacement of the popular trolley buses with diesel buses except, oddly enough, in Cambridge, where they continue to provide excellent service. They are part of the large fleet of vehicles that the modern MBTA system uses to transport present-day Bostonians—a far cry from the Winnissimmet Ferry of 1631 that started it all.

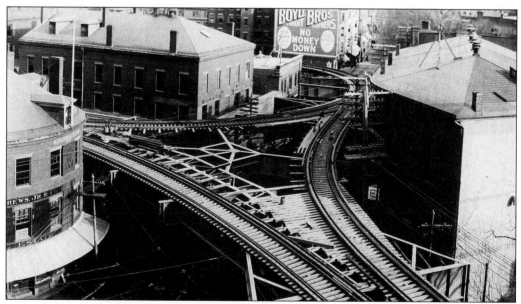

On a January afternoon in 1901 we are looking down at the intersection of Dudley and Washington Streets in Roxbury as construction on Boston's new elevated system is rushed to completion. Many of the buildings in this view are still in existence, including the one with the Boyle Brothers clothing advertisement.

One

THE EARLY YEARS

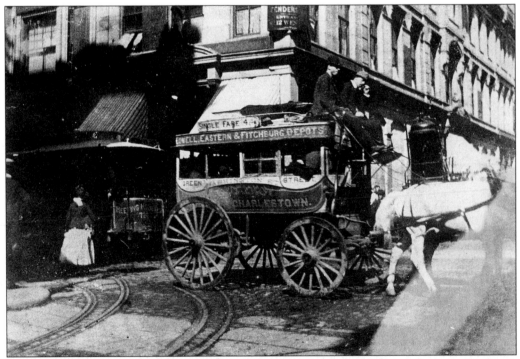

Typical of the omnibuses that once provided Boston's local transit service is this coach of Jacob Hathorne's Citizen's Line on the route from Northampton Street to Thompson Square in Charlestown. The photograph was taken at Washington and West Streets in 1889, shortly before Hathorne sold his omnibus lines to the West End Street Railway after being in business for 40 years.

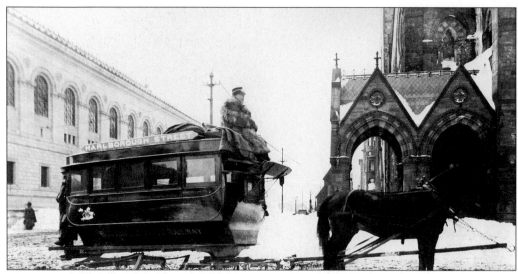

During the winter months when snow covered many streets for weeks at a time, sled runners replaced the wheels on many omnibuses, such as this one at Boylston Street in 1899, in front of the Boston Public Library. This coach was in use on the Marlborough Street Horse Car Line, which often went unplowed after winter storms. On the right is the new Old South Church, designed by Cummings and Sears and built in 1874.

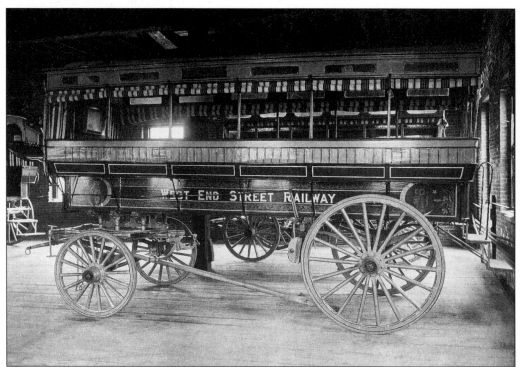

For summer use, many omnibus operators provided long, open-sided omnibuses for their patrons, which were called "barges" for reasons lost in antiquity. One such barge, Number 1091 of the West End Street Railway, was photographed in September 1897. These vehicles were quite popular for charter trips to parks and beach resorts.

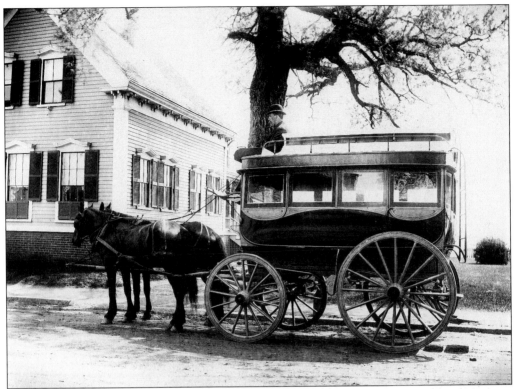

Many of Boston's omnibuses, rendered obsolete by the advent of the electric trolleys, found second careers serving passengers in suburban areas such as this coach sold to an operator in Swampscott, viewed on May 22, 1901.

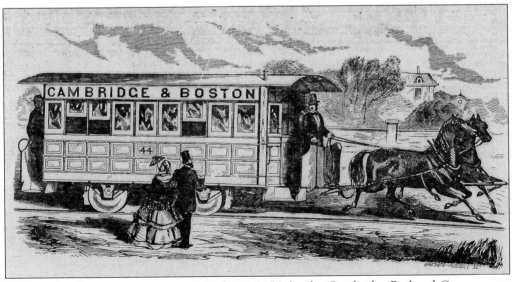

Boston's first horse car was run on March 26, 1856, by the Cambridge Railroad Company on the Harvard Square to Bowdoin Square route. The above print is a quite accurate depiction of the first cars; however, the car horses rarely trotted in the energetic manner shown here.

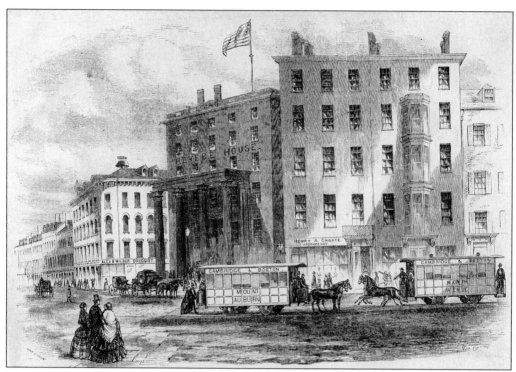

This print from the fall 1856 issue of *Ballou's Pictorial* shows a view of Bowdoin Square with two Cambridge Railroad Horsecars passing the well-known Revere House Hotel. Initial opposition to running the cars on Sunday, the Lord's Day, was overcome when the Cambridge Railroad pointed out that Sunday operation made it possible for the elderly and infirm to attend church services.

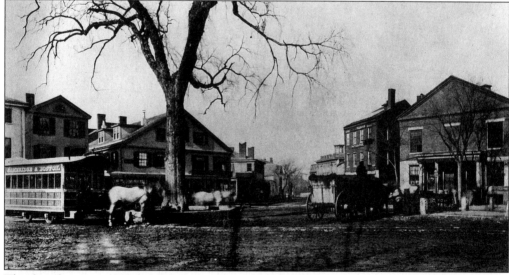

This bucolic view of Harvard Square, taken in 1858, shows a horsecar waiting between trips while the horses (attached to the wagon on the right) make use of the watering trough next to the sidewalk. In the days of horse power, these troughs were commonly found at busy squares and intersections.

14

The Highland Street Railway Company connected Roxbury and Boston via Warren Street and Shawmut Avenue. Its cars were painted in a handsome "Highland Plaid" scheme. Note the double-decker open car on the right.

During 1872, the great epizootic disease, or horse influenza, swept the Boston area causing the death or incapacitation of thousands of horses. The horse railway companies were so desperate to maintain service that they hired scores of men to pull the cars, as shown in this view of a South Boston-bound car on Washington Street.

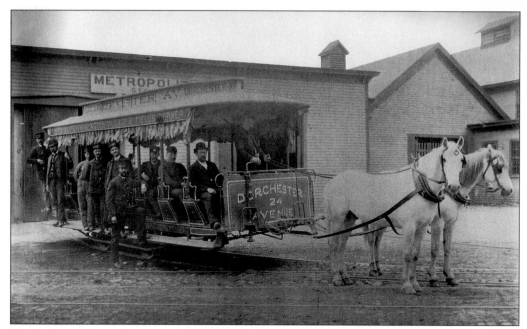

Here we see an open horse car of the Metropolitan Railroad Company, Boston's largest horse railway system, in front of the carbarn at Field's Corner in Dorchester, 1878. It appears that the railroad employees were not too busy to climb aboard the car and pose for the photographer.

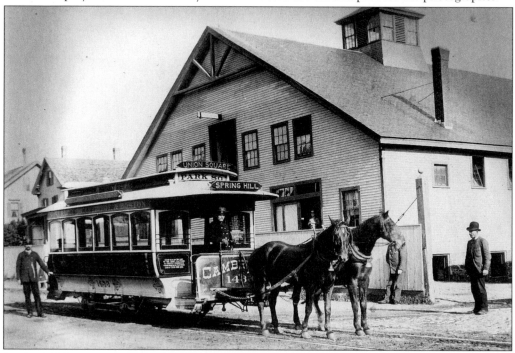

In this 1889 view we see a horse car of Boston's West End Street Railroad about to depart from the depot at Spring Hill in Somerville for the long trip to Park Square in Boston, via Union Square and Cambridge. Many cars of this type were converted to electric cars and remained in use for many years.

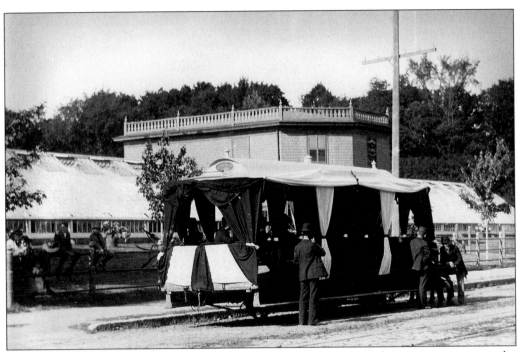

This open horse car, borrowed from its regular route on Longwood Avenue, is seen at the Mount Auburn Cemetery, c. 1890. Parked at the curb and draped in bunting, the car was apparently hired for a funeral party or Memorial Day event at the cemetery.

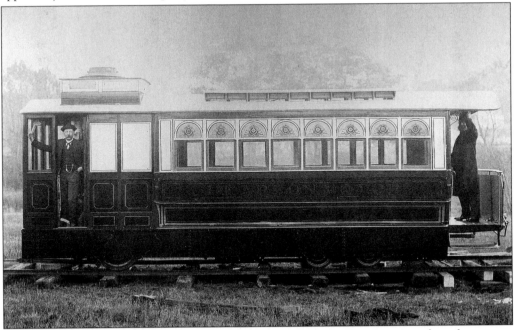

Between May 1865 and November 1867, steam-powered streetcars were used on four routes around Boston. The cars, such as the one above, were converted horse cars with upright steam boilers. Due to wear and tear on the light horsecar rails and complaints from the owners of frightened horses, they were given up.

WEST END STREET RAILWAY COMPANY.

ANNUAL SALE OF HORSES.

The last Grand Annual Sale of Car Horses by the West End Street Railway Company will take place at its Roxbury Crossing Stable, beginning March 20th, 1893, and continuing until May 2nd. During that time two thousand (2000) Horses, together with Harnesses, Collars, Blankets, Street Car Poles and Lead Bars will be on private sale, including a three days sale of horses by public auction; namely on April 4th, April 18th, and a closing out sale on May 2nd of all horses then unsold.

The special attention of the public is called to this sale from the fact that it will include not only horses of the class usually disposed of in the spring, but also a large number of horses of a better class which are being displaced by the introduction of electric cars.

The special attention of Superintendents of horse railroads is called to the fact that this Company has on sale almost everything pertaining to the operation of a horse railway; horse cars at very low prices, and all the equipment necessary for stable use as above stated.

We feel it our duty to inform our many patrons and the public that horses advertised for sale at West End Railroad Stables, at East Lenox Street, or Newcomb Street, Boston, are not the horses of the West End. Such sales are not and never have been sales by this Company. Our horses are sold at no other stable than Roxbury Crossing.

Persons attending the sale should take Tremont Street electric cars, marked Jamaica Plain, Roxbury Crossing, or Old Heath Street, all of which pass the stable door. This sale will be under the charge of Mr. H. W. PETERS, West End Street Railway Stables, Roxbury Crossing, Boston, and all communications should be so

With the rapid conversion of Boston's street railway system from horse to electric power, the West End Street Railway found itself with thousands of horses and hundreds of horse cars it no longer needed. However, the company found a ready market for most of this equipment and avidly pursued its profitable disposal as seen in this notice of March 1893.

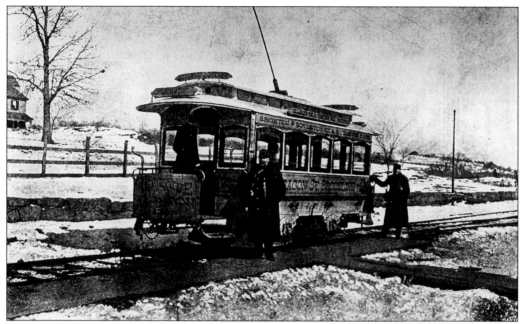

To those familiar with busy, bustling Cleveland Circle in Brookline, it is hard to recognize that this is the same location in February 1889, with one of the original Sprague Electric cars. In this view, Beacon Street has yet to be paved and only one house appears on the otherwise vacant landscape.

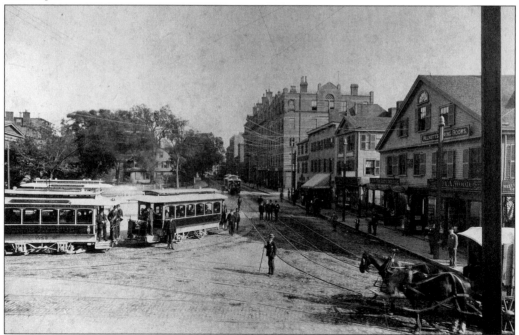

Harvard Square is shown here in the summer of 1889, with a Thompson-Houston Electric Car and trailer, as two horse cars approach the square from Massachusetts Avenue. The square had taken on a lively atmosphere compared to the earlier view. The wooden buildings on the right have survived with slight alterations.

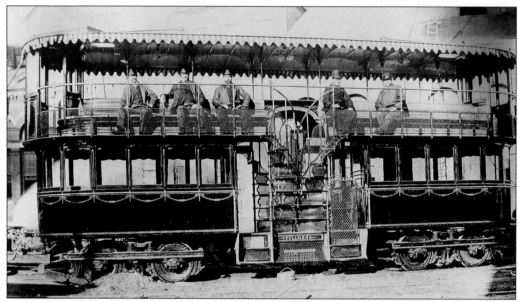

During 1890 and 1891, the West End system experimented with various types of electric cars in order to select a suitable type to become the standard. This big double-deck car, built by the Pullman Company, was tried for 40 days, during October and November 1891, on the Bowdoin Square-Harvard Square-North Cambridge Line. The operator's position was on the upper deck.

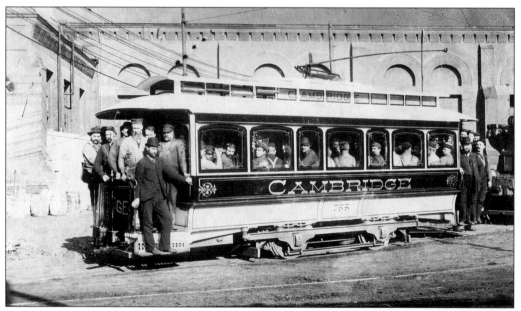

Here in the spring of 1892, at the Albany Street shops of the West End Street Railway, we see a capacity test being carried out to determine how many passengers can be fit in a trolley car. It was concluded that every standing passenger was entitled to 1.7 square feet of space in a car. The car in this picture is a former horse car rebuilt and equipped for electric operation.

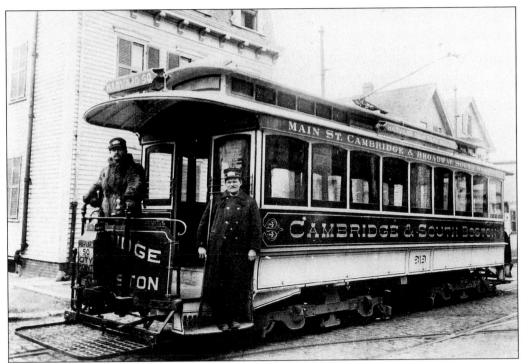

A "Standard Twenty Five Foot Car" of the West End system is about to leave City Point, South Boston, for Harvard Square, Cambridge, in February 1892. Just over 1,100 of these standard cars carried Boston riders from 1891 until 1928. Note the oil headlight and the heavy fur coat worn by the motorman—standard equipment for the time.

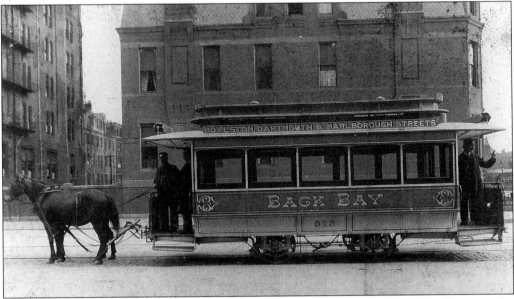

This view, taken in 1897 at Massachusetts Avenue and Marlborough Street, illustrates the gradual development of streetcar design during the 1890s. The Back Bay Horse Car was built in 1884 at the Roxbury Crossing shops, and, after the closure of the Back Bay Line, was sold to New York City, where it ran for another eight years.

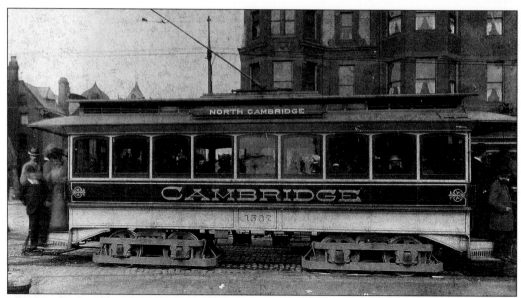

The Cambridge Electric Car, carrying a rush hour crowd to North Cambridge, is a larger, heavier version of the smaller horse car. In 1901 and 1902 the open-end platforms were enclosed due to a state order.

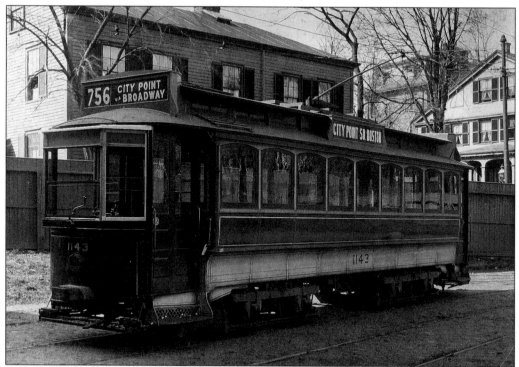

As the years passed, the standard cars, placed in service between 1891 and 1900, were updated by the installation of improvements such as enclosed end platforms, electric heat, and illuminated destination signs as shown by Car 1143, built in 1895 by the Laconia, NH, Car Company.

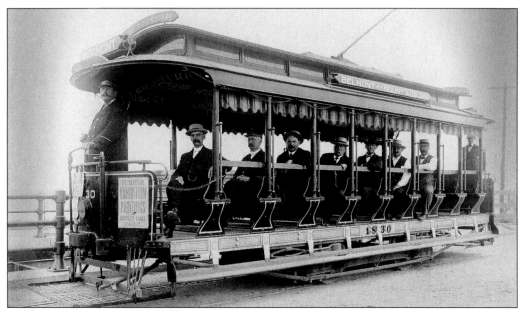

Here on August 8, 1906, we see the first trolley to cross the nearly completed Longfellow Bridge, which linked Cambridge and Boston. Since this was a test run, all the passengers were Boston Elevated officials, including Mr. Richard Hapgood (seated fourth from the left), who was the roadmaster responsible for track maintenance on the entire system.

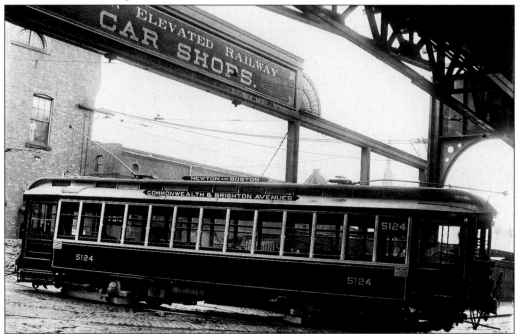

This large "Type Three" trolley, used on surface and rapid transit lines, was designed by the Boston Elevated Railway for a joint transit project with Boston Elevated, Bay State (Eastern Massachusetts), and the Boston & Worcester Railway Companies. They each purchased groups of this type of car, seen here at the Bartlett Street car shops in Roxbury. The Financial Panic of 1907 and 1908 and political skullduggery killed the project by 1912.

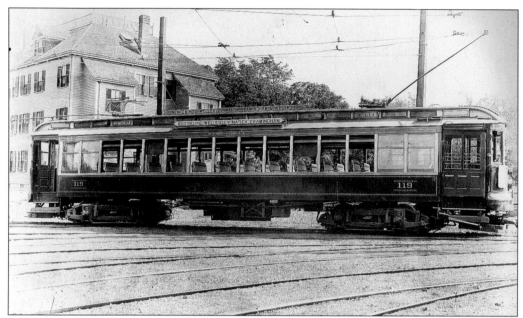

On July 9, 1907, one of Boston & Worcester Railway's large "Type Three" trolleys snapped at Cypress Street in Brookline. Called "Battleships" by the public, these big cars provided a fast ride from Park Square in Boston to downtown Worcester. Service ended in 1932 when most of the right-of-way was taken for the construction of present Route 9.

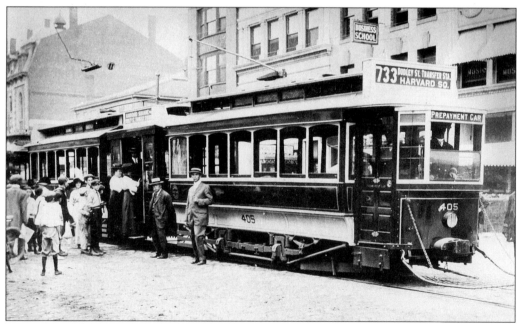

Service on today's Green Line system in Boston is supplied by modern articulated cars, as it is on many light rail systems worldwide. The articulated design enables cars to bend in the middle going around corners. The once-popular design was developed in May 1912 by John Lindall, chief equipment engineer of the Boston Elevated Company. One of the company's early articulated cars is seen here at Central Square in Cambridge en route to Dudley Street.

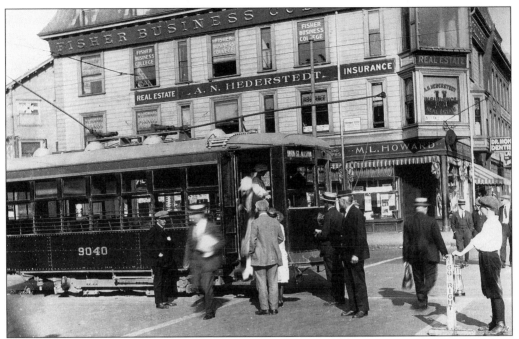

By c. 1917, many street railway companies were near bankruptcy and seeking to reduce operating costs. As a result, Charles Birney, of the Stone & Webster Engineering Company, designed the lightweight, one-man operated Birney Safety Car. Purchased in large numbers by the Boston Elevated and Eastern Massachusetts Street Railway systems, they proved impractical and were sold. Here is one such car at Central Square, Cambridge, in 1922.

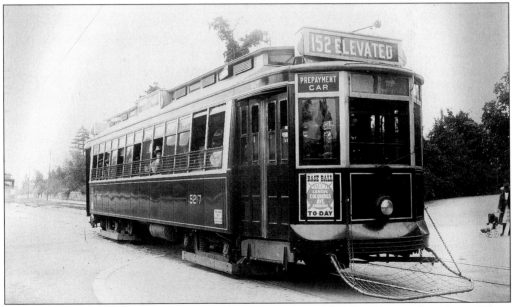

In this view of Blue Hill Avenue at Franklin Park on September 7, 1911, is a brand new "Type Four" trolley, designed by the Boston Elevated Engineering Department for use on lines with heavy patronage. These rugged cars provided excellent service through two world wars and were retired in 1952 after 41 years of service.

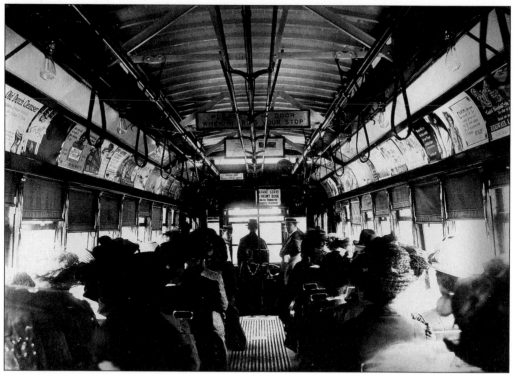

Here is an interior view of one of the large "Type Four" cars when new in September 1911. Accommodating 52 seated passengers, there was also room for 100 standees, for whom the leather hanging straps were provided.

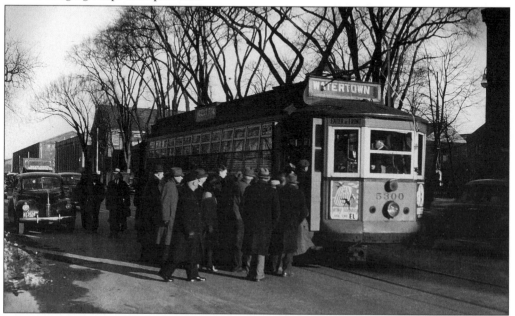

In December 1941, a "Type Four" trolley picks up a group of defense workers at the Watertown Arsenal, bound for Watertown Square. These cars carried record crowds when gasoline and tires were rationed and automobile production stopped during World War II.

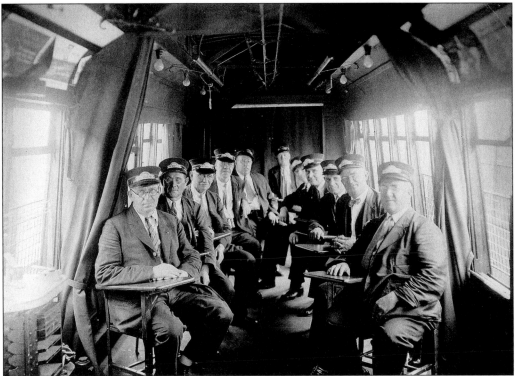

The Boston Elevated equipped several of its surface cars, including one "Type Four" car, as traveling classrooms providing refresher courses to employees on the electrical and braking equipment on the cars they operated. Here is one group of eager students aboard the trainer "Type Four" car, which was equipped with a movie projector and electrical equipment.

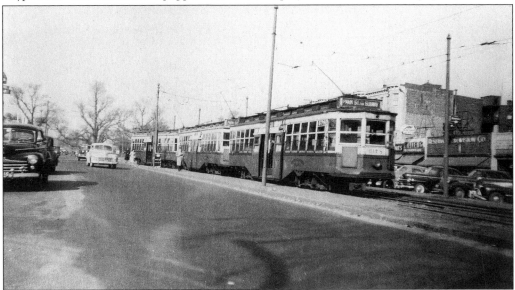

For 36 years, service on the heavy trolley lines entering the downtown subways comprising today's Green Line was provided by the rugged practical center door trolleys, as seen here at Cleveland Circle about to depart for the Park Street Station via Beacon Street in May 1948.

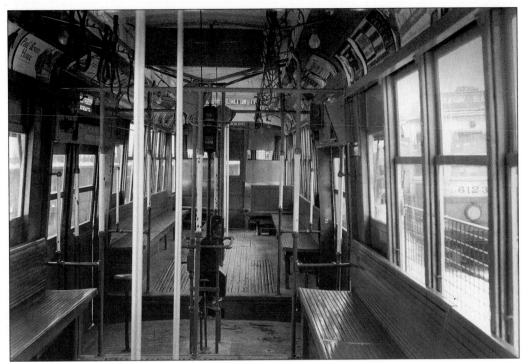

In order to better handle heavy Green Line riding, a group of the large center door cars were overhauled and given "Subway Interiors." This meant removing the forward facing seats and installing long benches, as on the Cambridge Subway cars, and painting the interiors green. This increased the capacity of the car from 175 to 225 passengers.

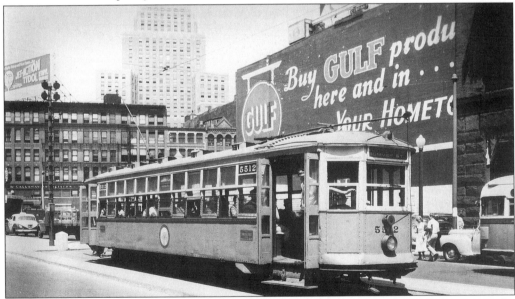

About to depart from Dewey Square at South Station for City Point in South Boston in the summer of 1948 is "Type Five" Trolley Number 5512. Four hundred and seventy-one of these lightweight, economical cars were purchased between 1922 and 1928 for use on medium density routes. The last ones were retired in 1959.

28

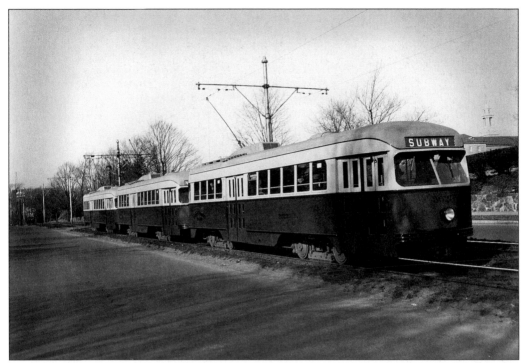

Between 1940 and 1951, the Boston system purchased over 300 "PCC Type" cars, most of which were used to replace the center door trolleys on the Green Line routes. Although fast and comfortable, the "PCC" cars, seen here on Commonwealth Avenue, could not handle heavy crowds as well as the center door cars they replaced.

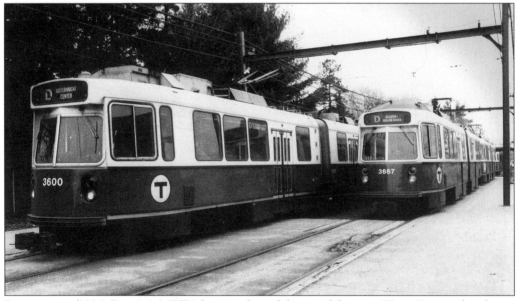

Beginning in 1986, Boston's MBTA began taking delivery of the new "Type 7" articulated cars, which replaced the last of the 42-year-old PCC cars. The "Type 7," built by Kinski-Sharyo of Japan, have proven to be high quality, rugged, and comfortable cars. This scene is at Waban Station on the Highland Branch.

For many years old Boston streetcars that were either obsolete or unsuitable found ready buyers on the second-hand equipment market, and were sold as far away as Maine, Arizona, and Brazil. Here we see a former Boston horse car sold to New York City in 1909 running in Lower Manhattan.

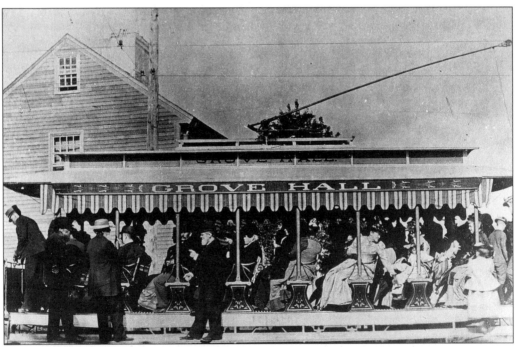

In June of 1891, the small Newburyport and Amesbury Street Railway lost all of its cars in a carhouse fire but was able to acquire nine cars from the West End Street Railway in Boston, some of which were virtually new. Here is an open car running in Newburyport still displaying its former Boston destination.

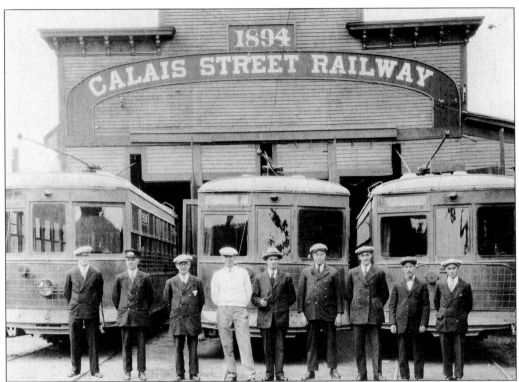

In 1926 the small trolley system in Calais, ME, acquired five "Birney Safety Cars" from Boston Elevated, which were too small for use in Boston. The Calais Street Railway served both Calais and the adjoining town of St. Stephen across the border in Canada.

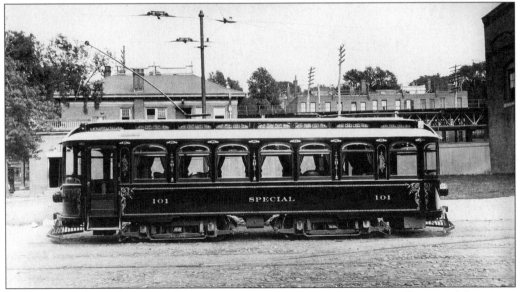

Beside the regular passenger trolleys there were many types of cars to handle special functions. One such car was Number 101, the private parlor car of Major General William A. Bancroft, president of the Boston Elevated Railway. Here is the 101 at Bartlett Street in Roxbury in June 1904.

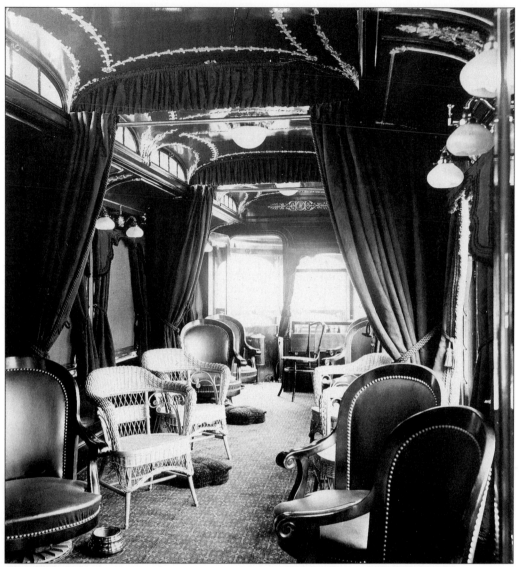

The plush interior of Car 101 was a sea of green velvet, silk, and brass trimmings. General Bancroft traveled as far afield as Beverly Cove, Springfield, and Newport, RI, in this luxurious parlor car, which ended up as a roadside restaurant in Attleboro, MA.

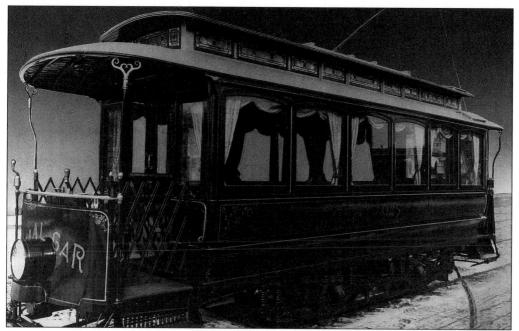

Luxury trolley travel was also available to the general public at reasonable charter rates. The West End Street Railway and its successor, the Boston Elevated, had several parlor cars available for hire, such as Number 925, seen in this 1894 view.

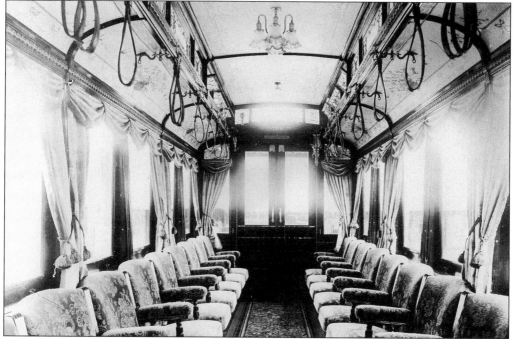

Here is an interior view of Car 924. The J.M. Jones Car Works of Troy, NY, built cars 924 and 925 in 1894. They carried such visiting dignitaries as George M. Pullman in August 1897 and President William McKinley and his cabinet on an inspection tour of Boston's new subway on February 17, 1899.

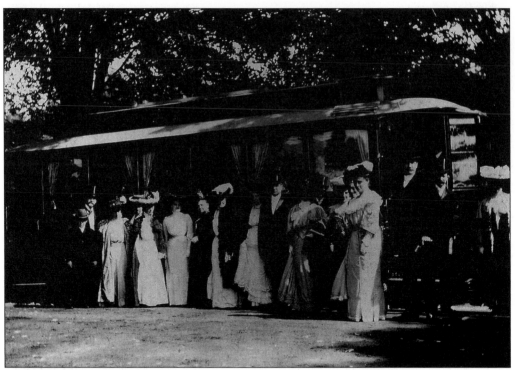

In this 1903 view we see an elegantly garbed group, probably a wedding party, about to embark on one of the 1894 parlor cars.

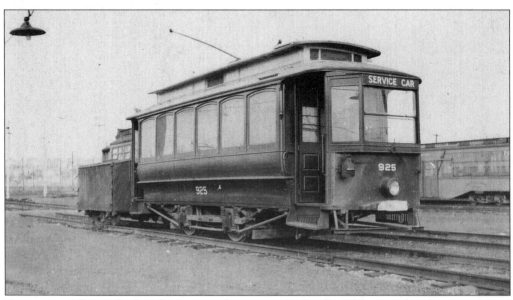

From a peacock to a feather duster, in its later years, Parlor Car 925 was reduced to serving as a welding tool car as seen in this 1936 view. This car is now in a transit museum where hopefully it will be restored to its former glory.

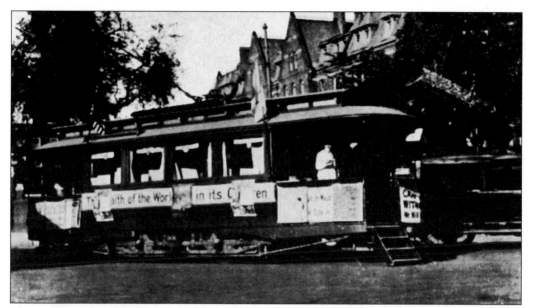

The big Bay State/Eastern Massachusetts Street Railway also had a parlor car, named the *Lawrence*, which featured open balconies on each end. The *Lawrence* is shown here taking part in a World War I food conservation drive in Harvard Square, Cambridge, in 1918.

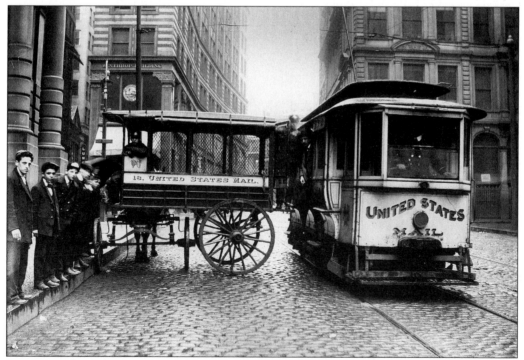

From 1895 through 1915, the U.S. Mail was carried on special cars between the main post office and branch postal stations. The cars were painted white with red and gilt lettering and had the right-of-way over all other street traffic along with police and fire vehicles. This view was taken in Post Office Square, Boston, in May of 1907.

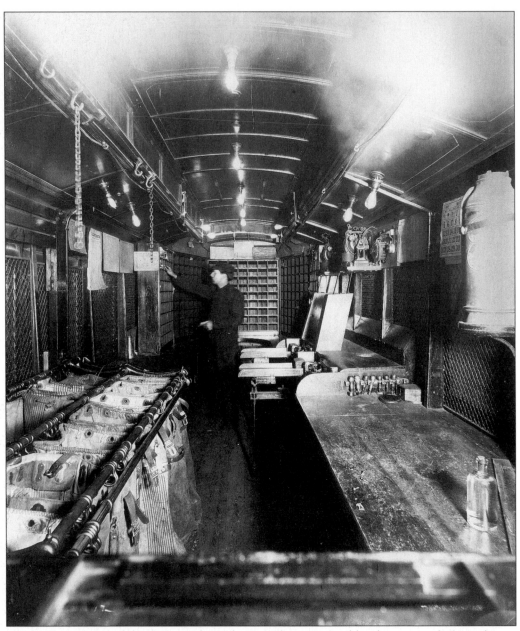

Here is the interior of the same mail car showing the sorting tables, bins, canceling machines, and mail sacks. The mail was sorted and canceled as the cars traveled between the post offices, saving a great amount of time.

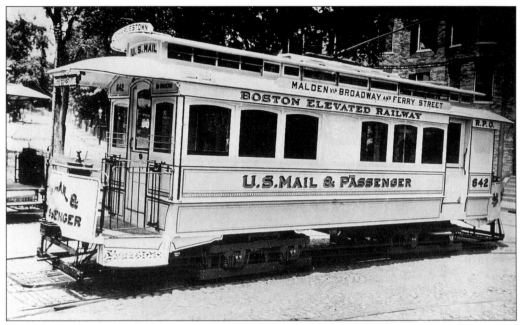

While most U.S. Mail trolleys carried only mail and postal employees, the Boston Elevated had one car that carried passengers as well. Seen here at the Bartlett Street Car Shops in 1901, it was regularly assigned to the long route from Malden Square to Post Office Square in downtown Boston.

Prior to 1920, the Boston Elevated Company paid its 7,000 employees in cash, and several trolleys fitted up as traveling paymasters' offices visited the more than 40 car house and shop facilities on pay day. Car 448, converted from a U.S. Mail car to a pay car, is seen at the Grove Hall Station paying the men. Note that the windows were painted over to avoid prying eyes. This view dates from March 1912.

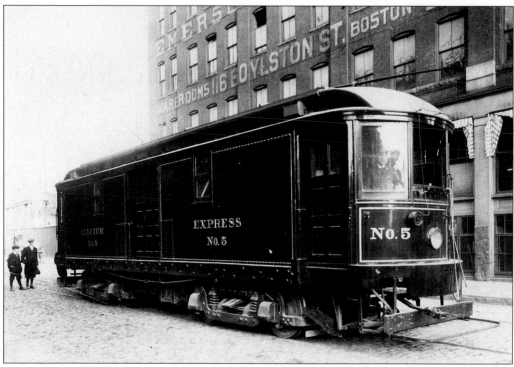

Not only did the trolley lines provide passenger and mail service but also freight and package express service between Boston, Worcester, Springfield, Brockton, and Fall River, MA, and Newport and Providence, RI, as well as other points. Here is an electric freight car of the Bay State Street Railway on Harrison Avenue in Boston in November 1922.

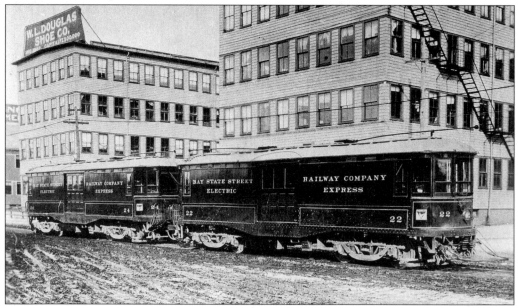

A two-car train of Bay State Street Railway express cars is about to leave the big Brockton plant of the Douglas Shoe Company with a consignment of shoes for Boston. At one time Brockton was a center for the shoe industry in the United States. This view dates from 1914.

For several years Boston Elevated hauled tank cars of molasses from Copp's Hill Wharf on Commercial Street in Boston to the Purity Distilling Company in East Cambridge, where it was converted into industrial alcohol. Here is a molasses train at the Central Power Station in early 1917. This traffic ended on January 15, 1919, as a result of the famous Molasses Flood at Copp's Hill Wharf.

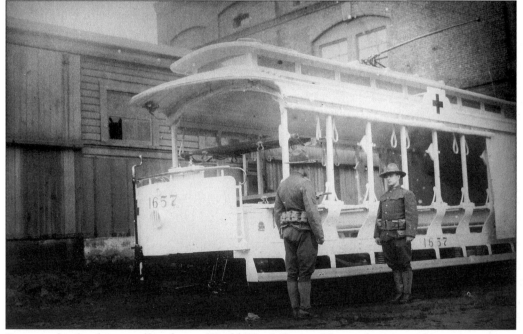

Doing its bit for the war effort during World War I, Boston Elevated converted an open car into an ambulance for use by the army in transporting returning wounded troops from France. Seen here at the Bartlett Street car shops on February 15, 1918, the car saw only limited use due to the advent of motor ambulances.

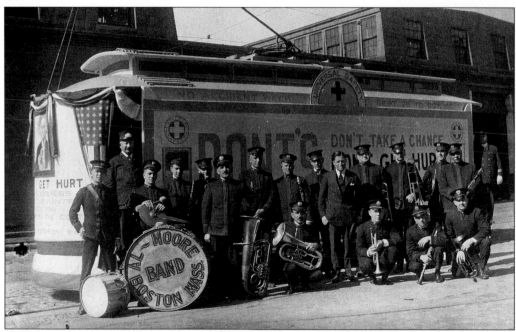

Let's strike up the band, the Al Moore Band that is, for the 1921 Public Safety Awareness Campaign. The practice of using an open streetcar festooned with advertising messages and carrying a brass band was a longtime Boston custom, dating from the horse car days. Al Moore is the gentleman in the suit in the center.

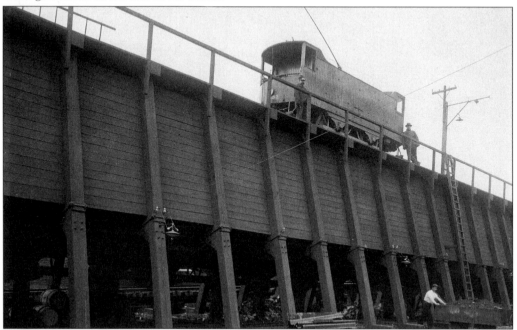

For many years Boston Elevated employed a fleet of trolley coal cars to distribute coal to power stations and car houses around the system. Here in 1901 we see a coal car depositing its load on the coal trestle at the Harvard Power Station, now the site of a Harvard University dormitory at Boylston Street and Memorial Drive.

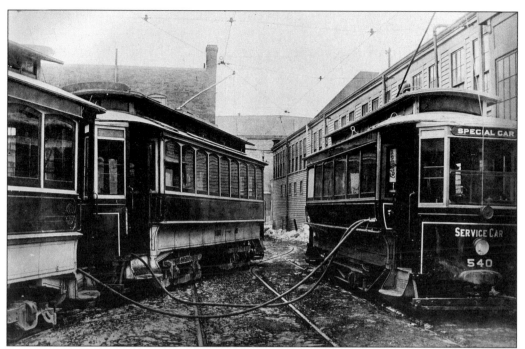

In the days when trolley cars had thick plush seat cushions, keeping them clean was a problem that Boston Elevated solved by equipping an old trolley with high-powered vacuum equipment. Here we see Vacuum Cleaner Car 540 at the North Point Car House in South Boston in 1907. This car traveled about, visiting all the car houses on a regular schedule cleaning seat cushions.

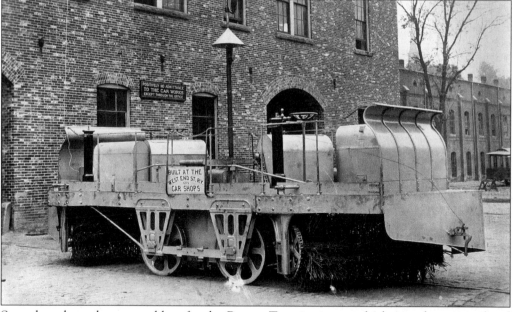

Snow has always been a problem for the Boston Transit system, which must keep its railroad system open even in the worst winter storms. Here is an early electric snow sweeper at the Bartlett Street car shops in November 1889. Protection for the operating crew was not a high priority at this time.

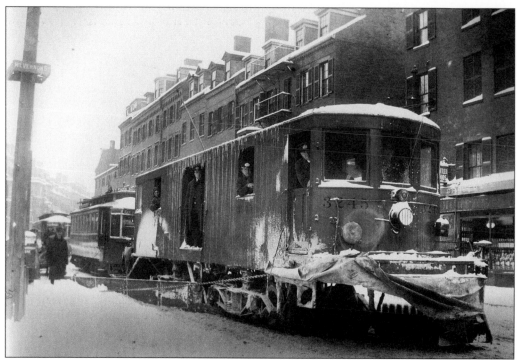

The equipment as well as the conditions for the operating crew had improved immensely when this view of a snow sweeper on Charles Street at Revere Street was snapped in 1925. Both the Boston Elevated and Eastern Massachusetts systems had a large fleet of snow sweepers such as this one built by the Russell Car Company of Ridgeway, PA, a leading builder of snow fighting equipment for American transit systems.

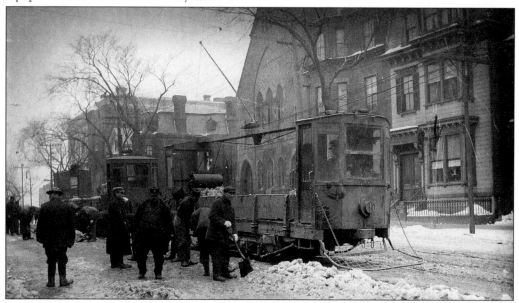

Not only plowing, but also the removal of accumulated snow and ice from the streets was handled by the Boston Elevated Company. During the winter of 1915 an ambitious looking crew is shoveling snow into work cars on East Broadway in South Boston.

Two
ROLLING ON RUBBER

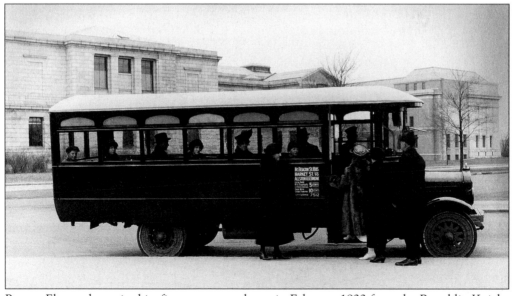

Boston Elevated acquired its first two motor buses in February 1922 from the Republic-Knight Motors Company for use on North Beacon Street in Brighton. Here is one of the two coaches is set up for a publicity shot at the rear of the Boston Museum of Fine Arts, which provided a suitable backdrop.

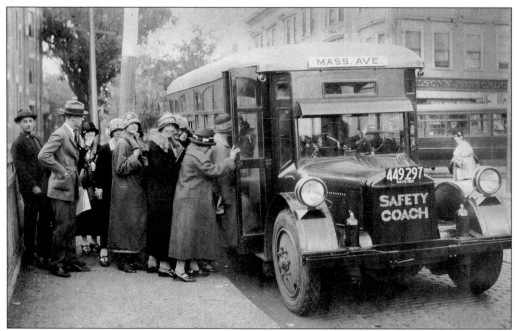

Don't push girls, there's room for everyone! This August 1924 view shows a "Fageol Safety Coach" in use on the route from Central Square in Cambridge to the Cottage Farm Bridge. Frank Fageol was one of the pioneer bus manufacturers in America. His firm remained in business until about 1960.

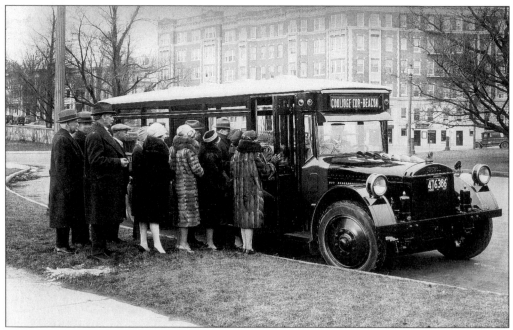

From 1927 until 1930, Boston Elevated operated an extra fare (25¢) deluxe bus line from Beacon Street in Brookline to Scollay Square in Boston. The regular bus fare was 10¢. Just look at all those fashionable fur coats!

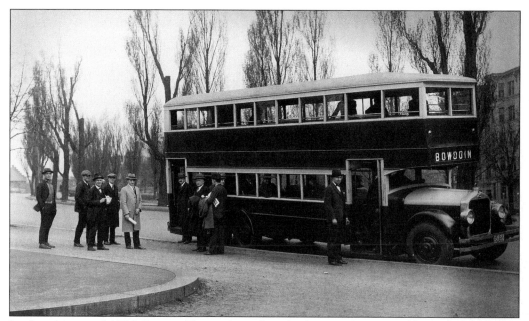

In the summer of 1926, Boston Elevated purchased a large Safeway Double Deck Bus, which operated for a short time on the route from the Fenway to North Station. While the "El" hoped to operate double deck buses on a number of routes as in New York and Chicago, state and city authorities were not partial to the idea and the upper deck was removed. The bus operated as a single-decker for a number of years.

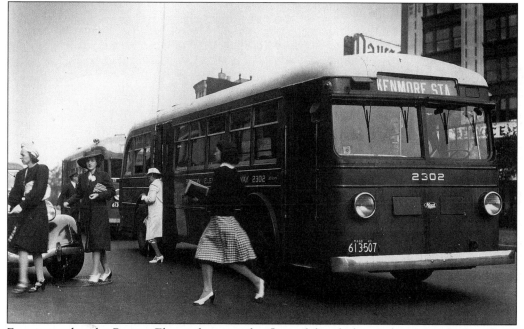

For over a decade, Boston Elevated operated a fleet of diesel-electric buses in which a diesel engine powered a generator that fed power to an electric motor on the rear axle of the bus. Fashionably dressed ladies are shown here alighting from two such buses in Kenmore Square in the summer of 1940.

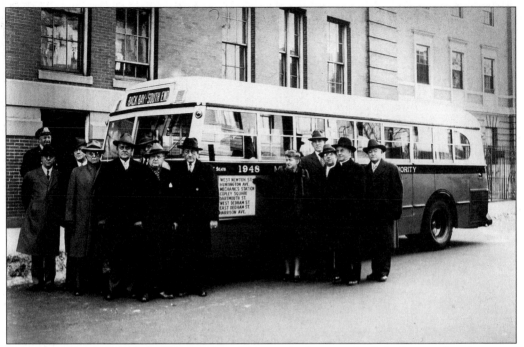

On December 10, 1947, the Metropolitan Transit Authority, which had recently taken over operation of the Boston Elevated system, established a new bus route linking Back Bay with the South End. Various system officials and local representatives took advantage of the occasion for a photo opportunity.

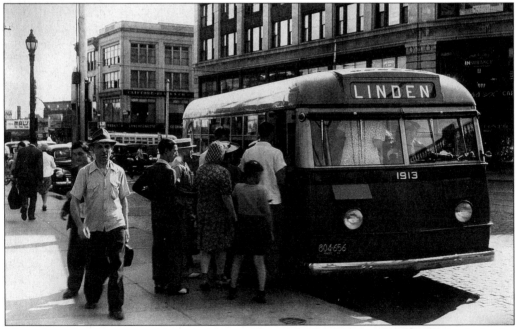

Motor buses had become an important means of providing public transit in local suburbs by the late 1930s. This view on July 22, 1942, shows riders crowding aboard a bus bound for Linden in the bustling Malden Square business district.

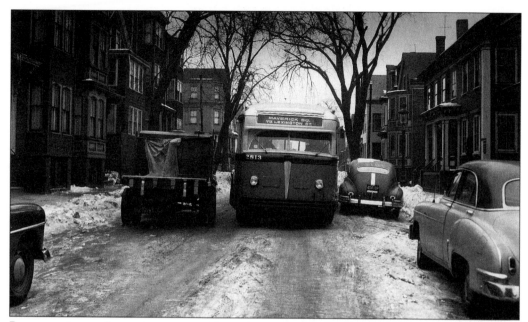

Bus operation on Boston's narrow residential streets was not ideal under normal conditions but became quite difficult during the winter, when many streets were poorly plowed. In January of 1954 this bus slowly eased its way along Lexington Street in East Boston bound for Maverick Square.

For many years Atlantic Avenue was the most colorful and vibrant transit artery in Boston, with horse-drawn wagons, large trucks, buses, trolley cars, and freight trains all vying for street space while elevated trains rumbled overhead. In this 1926 winter view, we see a Rawding Bus Line bus heading for the Fish Pier at Atlantic Avenue and High Street.

The red-and-white buses of the New England Transportation Company were once a familiar sight throughout southern New England. A subsidiary of the New Haven Railroad, the firm's buses served as both feeders to and replacements for train service. This 1951 photograph was taken on Blue Hill Avenue at Morton Street. (Collection of Kevin T. Farrell.)

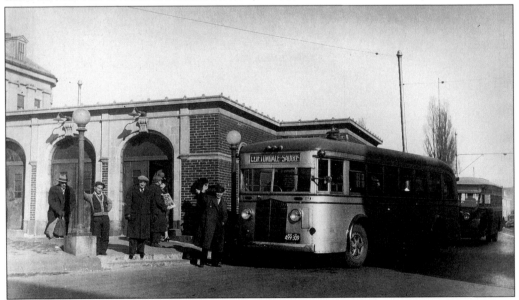

For many years some Boston suburbs were served by small privately owned bus companies that acted as feeders to the big Boston Elevated Company. Here we see a bus of one such company, Hart Bus Lines, at the Maverick Square Station in East Boston, about to depart for Saugus and Cliftondale in January 1940.

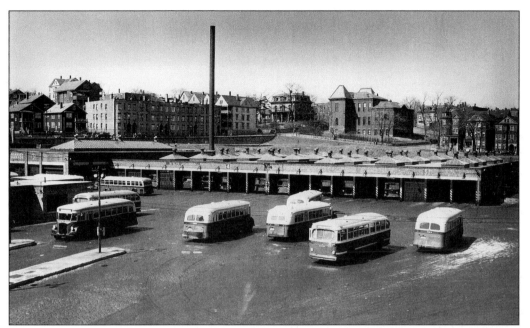

Ever since the early 1870s, the site at the corner of Washington and Bartlett Streets in Roxbury has served as a maintenance facility for transit vehicles including horse cars, electric trolleys, elevated trains, and, most recently, motor buses, as seen in this April 1947 view. Fifty years after this photograph was taken, the Bartlett Street Garage still serves as a major MBTA bus maintenance facility. Many of the buildings in this view are still standing.

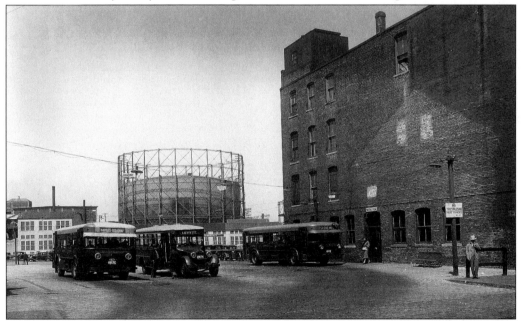

One of the primary functions of the motor bus in Boston was to provide feeder service to stations on the subway and elevated lines. Here we see several buses awaiting riders from the Cambridge Subway Line at Kendall Square on May 17, 1933. Note the large gasometer in the background, a once common sight in the Boston area.

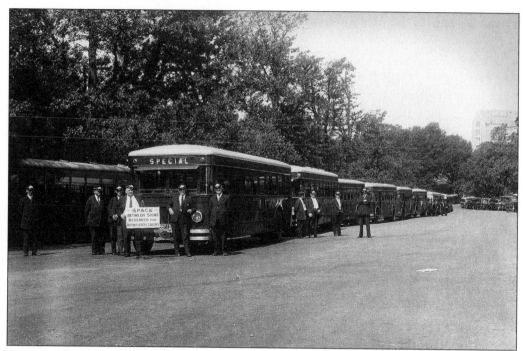

A major advantage of the motor bus was its ability to carry large groups on outings and charter trips to areas not directly served by rail lines. Here is a group of Boston Elevated coaches lined up at Boston College during an anniversary celebration for Boston's William Cardinal O'Connell on June 9, 1934.

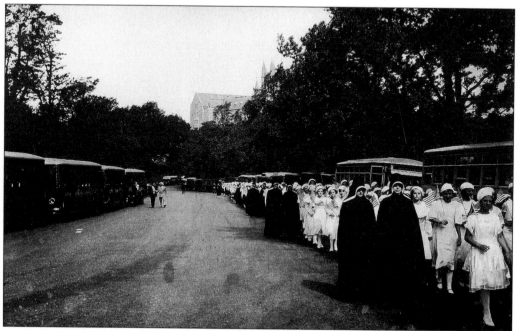

In this view, the celebration for the cardinal has concluded and, with the buildings of Boston College in the background, a long line of schoolchildren are being ushered back to their buses by serious-faced nuns, who tolerated no undue frivolity.

This MBTA bus, posed in front of the Ruggles Station in Roxbury, is a standard General Motors City Bus. Thousands have been produced, and they are familiar to nearly all Americans. The employees of the MBTA totally restored this bus to its 1950s "like new" condition at the Everett shops entirely at their own expense for historic preservation.

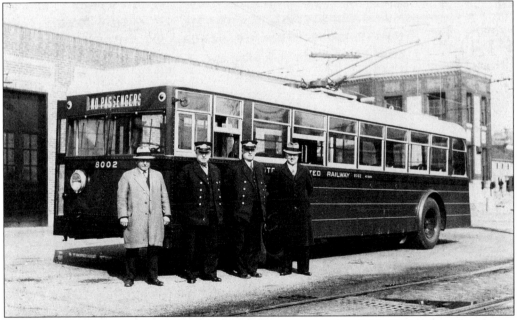

Electric trolley buses were introduced in the Boston area on April 11, 1936, when they began operating between Lechmere and Harvard Squares in Cambridge. Here is one of the original coaches at Harvard Square with company supervisors and instructors several days before regular operation began.

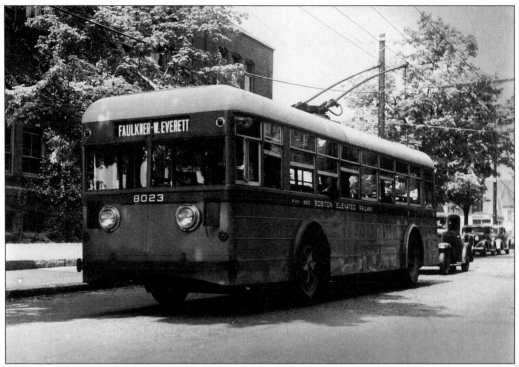

By 1939, nearly all transit service in the cities of Everett and Malden was provided by fast, quiet trolley buses such as this vehicle bound for West Everett from the Everett Elevated Station. It was built in 1937 by the Pullman Company plant in Worcester, MA.

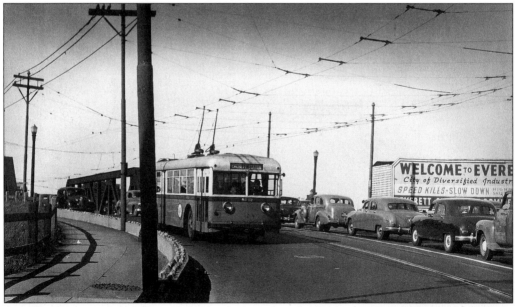

A trolley bus en route to Everett Station passes over the Boston & Maine Railroad bridge on Broadway with a civic booster billboard in the background welcoming us to Everett. Just in front of the billboard are two Kaiser-Fraser automobiles, manufactured by Henry J. Kaiser in the years after World War II.

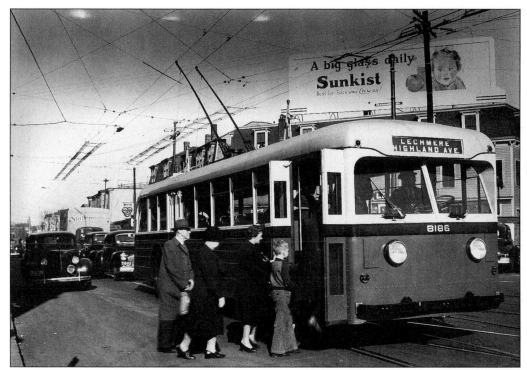

On November 8, 1941, these lucky residents of Somerville boarded a brand new Pullman-built trolley bus in Davis Square en route to the Lechmere Square El Station. World War II put a stop to the expansion of the trolley bus system, which did not resume until the summer of 1946.

With the end of World War II, the trolley bus expansion program resumed with the conversion of the long route from the Sullivan Square Elevated Station to Clarendon Hill in Somerville. A trolley is shown here leaving the Sullivan Square El Station bound for Clarendon Hill.

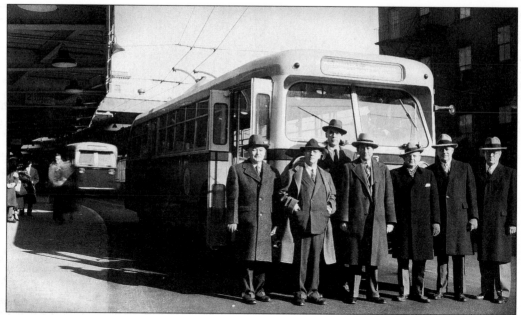

At the Dudley Street Station on a bright January morning in 1949, the top management of the MTA, the successor to Boston Elevated, inspects the new trolley bus system, which had just been installed to serve Roxbury and Dorchester. Second from the left, with his hands in his pockets, is Edward Dana, who served as general manager of the Boston Transit system for over 50 years.

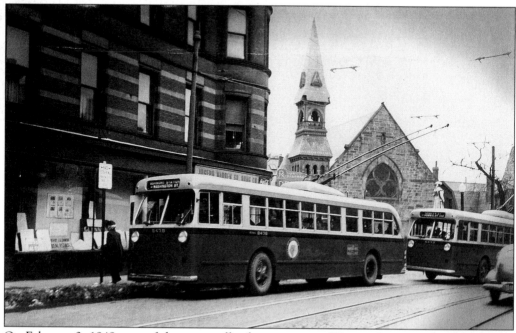

On February 3, 1949, two of the new trolley buses pause at Warren Square in Roxbury at the junction of Warren and Woodbine Streets. Note the handsome stone building of the Woodbine Street Church in the background behind the Warren Monument, visible above the second trolley bus.

The latest in up-to-date maintenance facilities were provided to maintain Boston's trolley bus system, as evidenced by this January 1952 photograph of the Eagle Street Maintenance Center in the East Boston.

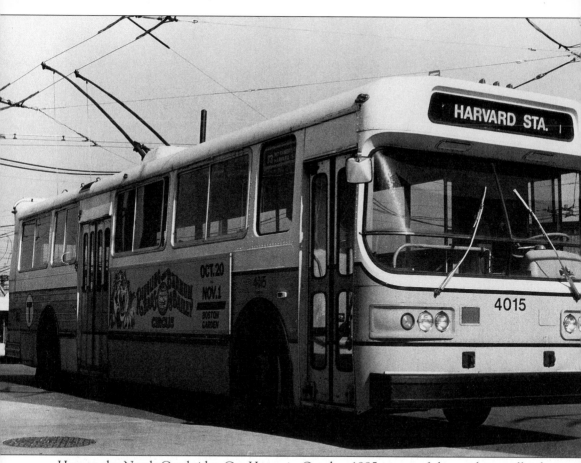

Here at the North Cambridge Car House in October 1985 is one of the modern trolley buses presently serving sections of Cambridge, Belmont, and Watertown. It was built by Flyer Industries of Winnipeg, Manitoba, Canada.

Three
BOSTON GOES RAPID TRANSIT

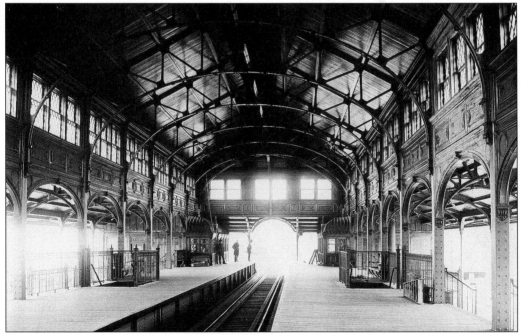

This view of the elevated train passenger platform at the Dudley Street Station shows the amount of effort expended to provide an attractive as well as efficient station. Note the thoughtful use of mahogany, leaded glass, and brass trim in the station.

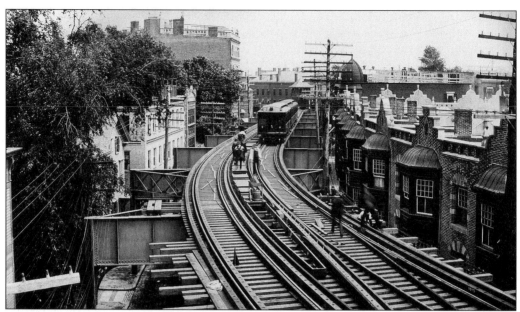

Workmen were still putting finishing touches on the elevated structure in this July 30, 1901 view, although the El system opened on June 10. This photograph was taken looking north on Washington Street toward Dudley Street and, interestingly, the large apartment house on the right was brand new at the time, its desirability apparently not affected by the noisy elevated trains.

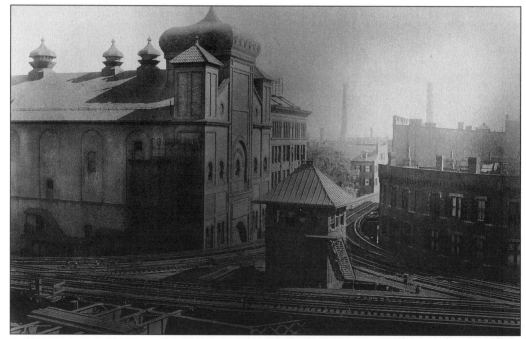

A busy junction point on the El system was at the intersection of Washington and Castle Streets, where Signal Tower "D" controlled train movements on the lines coming from Dudley Street, Atlantic Avenue, and the subway. In the background is the well-known Columbia Theatre, which was featuring burlesque shows in this June 25, 1903 scene.

This view, from September 23, 1901, looks toward the El's Castle Street Junction from Harrison Avenue. The trolley car is on the bridge carrying Washington Street over the New Haven and Boston & Albany Railroad tracks, while the Columbia Theatre looms on the left. Today, the El lines are gone and the depressed rail right-of-way accommodates the Massachusetts Turnpike and MBTA Commuter Rail trains.

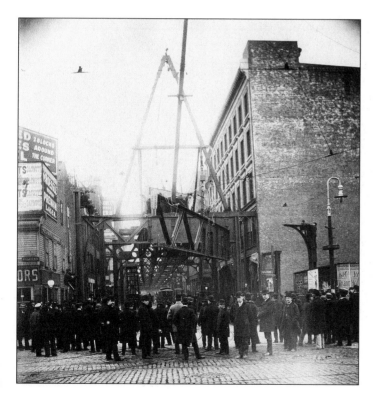

On the cool morning of April 1, 1901, an interested crowd of "sidewalk superintendents" watched a section of steelwork being hoisted into place on the Atlantic Avenue Elevated at the corner of Atlantic Avenue and Beach Street. Construction sites were not blocked off in this era when the public was expected to exercise responsibility rather than file lawsuits.

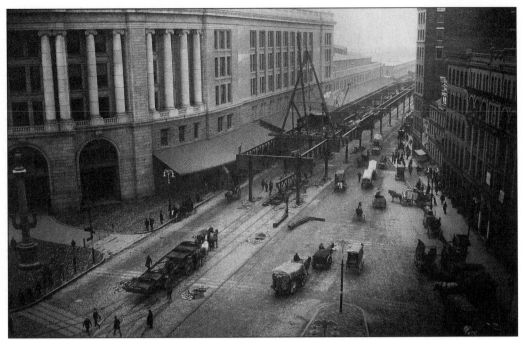

In this photograph, taken looking across Dewey Square toward the recently completed South Station on April 11, 1901, the construction of the Atlantic Avenue Elevated Line is progressing and would be completed in four months. In the foreground, a six-horse team is delivering a large cross section of steel, which would soon be hoisted into place.

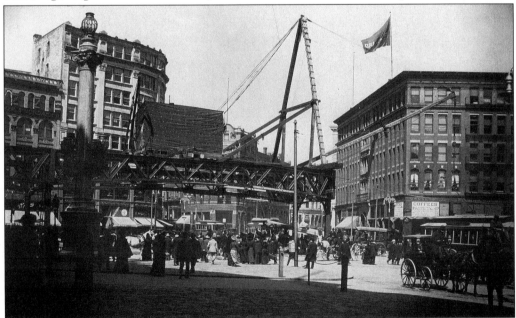

A day later, the new El structure had advanced part of the way across Dewey Square, as seen from the front entrance to the South Station. The large Wentworth Building to the right fell victim to highway construction in the 1950s. Note the hackney carriage (right) awaiting a fare, once a common sight on big city streets.

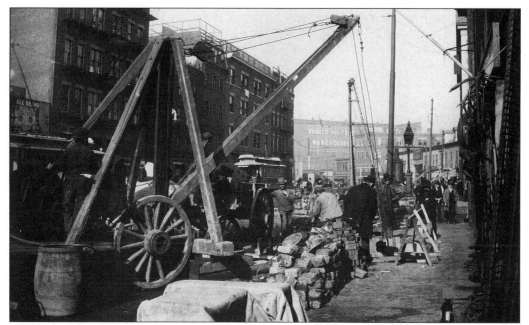

It is November 9, 1899, and this view is looking north along busy Commercial Street on Boston's Waterfront. Amidst the jumble of traffic and commercial activity, the workmen are building the base piers to hold the steel upright girders for the Atlantic Avenue El Line.

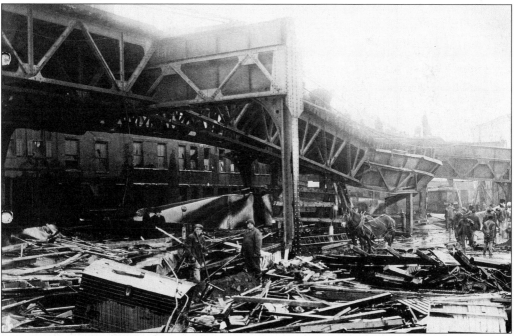

Here is the aftermath of the famous molasses tank collapse on January 15, 1919, on Commercial Street, which killed 21 persons and injured over 40 others. As the big tank, containing 2.3 million gallons of molasses, split apart, a 20-foot wave of molasses surged across Commercial Street, knocking down a section of the Atlantic Avenue El Line and drowning residents on the first two floors of the apartment house on the left, which is still standing.

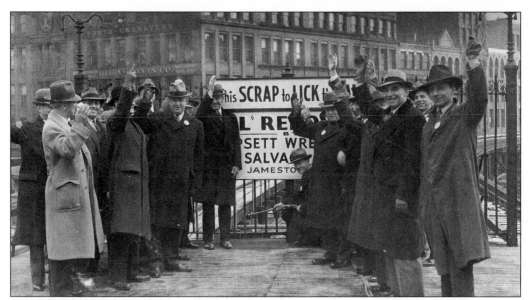

Opened on August 22, 1901, the Atlantic Avenue El Line closed on October 1, 1938. The El Line stood idle for nearly four years as debate ensued over whether to tear it down or re-open it for operation. With the advent of World War II, and the big demand for high-grade scrap steel, the question was settled. This photograph, taken on March 16, 1942, shows demolition getting underway, with Boston Elevated General Manager Edward Dana holding a cutting torch as Governor Saltonstall, nest to the letter L on the sign, and other officials cheer.

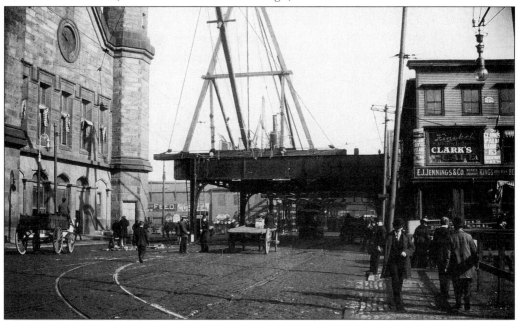

Construction of the Charlestown Elevated Line is shown here underway on November 8, 1900, at the corner of Canal and Haverhill Streets, above an assortment of horse-drawn vehicles. The impressive stone building on the left is the depot of the Fitchburg Railroad; built in 1848, it was demolished in 1926. The upper floor of the station contained a hall where the "Swedish Nightingale" Jenny Lind performed on October 11 and 12, 1850.

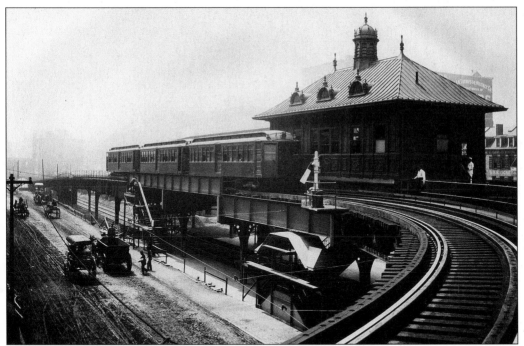

On July 19, 1901 an El train bound for Sullivan Square in Charlestown stopped at the North Station Elevated Station, designed by Alexander W. Longfellow, who designed all the stations on the original elevated system. This photograph was taken looking toward Haymarket Square with Haverhill Street in the foreground.

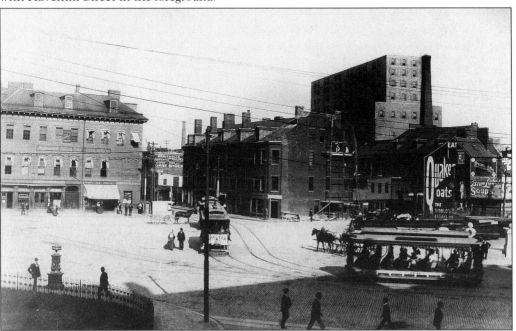

In this September 22, 1899 view of City Square in Charlestown, construction of the Elevated was about to begin as evidenced by the pile of steelwork just under the Quaker Oats sign. The tall brick structure in the background is the grain elevator of the Boston & Maine Railroad.

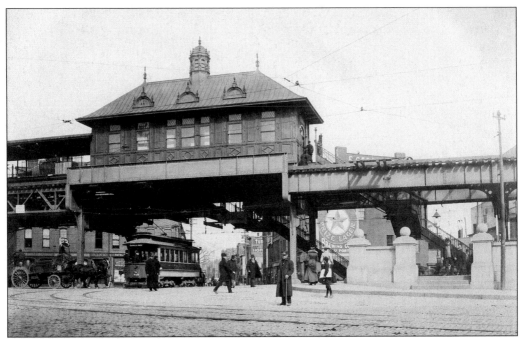

Looking across City Square in the same direction as the previous view, but on March 13, 1901, we see a Bunker Hill-bound trolley pass under the new City Square El Station as workmen put the finishing touches on the El structure, which began operation on June 10, 1901.

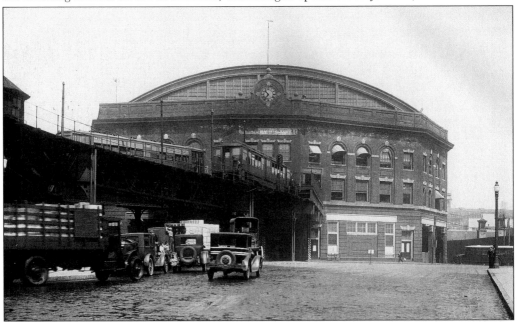

Looking from Main Street in Charlestown into Sullivan Square we see the big Elevated Terminal, which dominated the square for 75 years. In this view, a trolley car and an elevated train can be seen entering the upper level of the terminal as a motor bus enters the lower level on the right. This classic structure also contained offices, stores, and restaurants. It was one of the largest transit stations in America when it was photographed in September 1927.

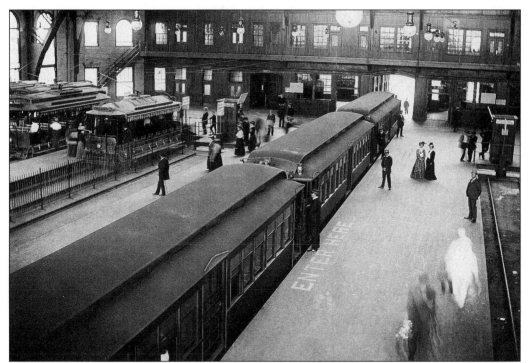

The big train shed at the Sullivan Square Terminal contained ten tracks for trolley cars and one track for El trains, which looped through the building. In this photograph, taken on July 26, 1901, an El train prepares to depart for downtown Boston as passengers board trolleys for Malden and Everett on the left.

In later years, Sullivan Square Terminal was used by motor buses and trolley buses as well as by trolley cars and elevated trains. In this 1956 view, a bus is about to depart from the terminal's lower level for Central Square in Cambridge.

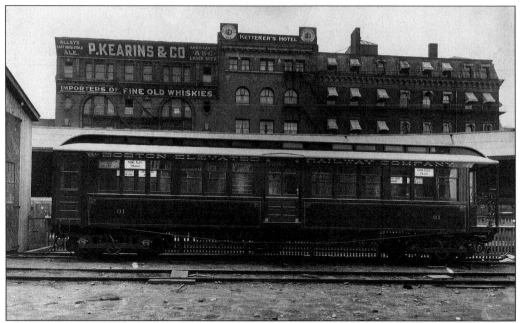

Seen at the North Station on May 5, 1900, is Boston's first elevated car, built by the Wason Car Company of Springfield, MA. The car underwent equipment tests for the General Electric Company. The buildings in the background are on Canal Street in Boston.

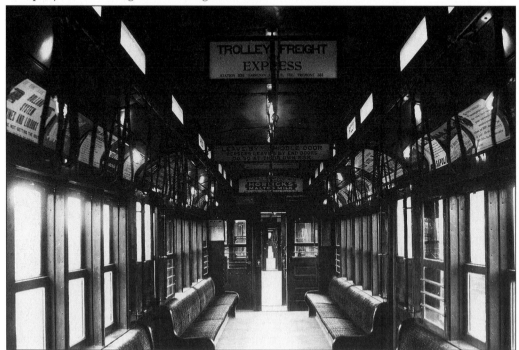

Boston's early elevated cars featured varnished interiors, mottled red-and-black plush seats, and polished brass fittings. In this photograph, taken on January 29, 1913, we are looking through the interior of a six-car train. Note the advertisement for the Trolley Freight and Package Express Service.

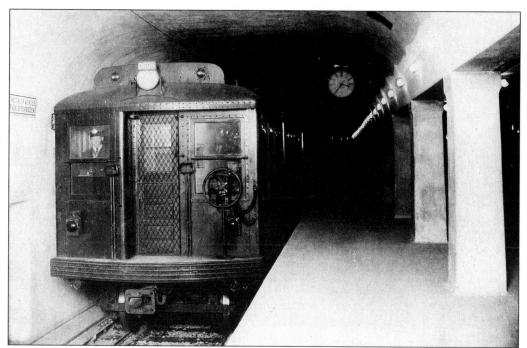

The Cambridge Subway, which over the years would become Boston's most heavily used rapid transit line, opened on March 23, 1912. Extensions to the original line carried out over the years brought the trains to Ashmont, Braintree, and Alewife. This view was taken on March 20, 1912, at Harvard Square; the Cambridge Subway is now known as the Red Line.

In this July 1916 view at Andrew Square in South Boston, the Cambridge Subway was extended from South Station to this point, which resulted in much of Andrew Square being dug up and buildings moved. In the days before tetanus shots, some local children pose barefoot amidst the construction debris.

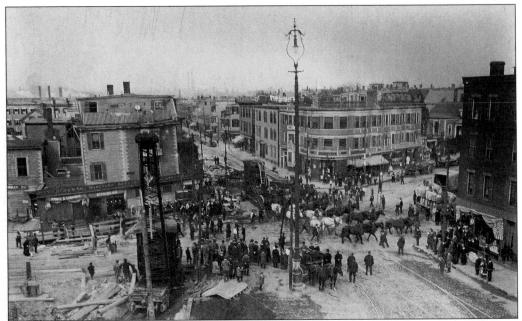

Horses still played a big part in construction projects when the Cambridge to Dorchester Subway was being extended to Andrew Square. Looking across the square from Boston Street on October 24, 1916, we see a team of 16 horses hauling a large steam-powered crane into the square as another crane stands in the foreground (left).

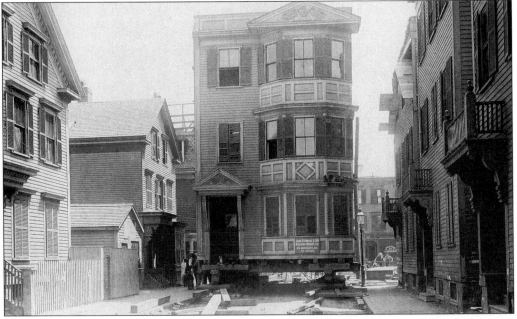

As part of the subway project, a number of triple-deckers had to be moved to make way for the Andrew Square Transfer Station. This house was moved to a new location from Dexter Street on June 2, 1916. House moving was very common at this time and the contractor moving this house, John Cavanaugh & Son, had a long and respected reputation as Boston's leading building mover.

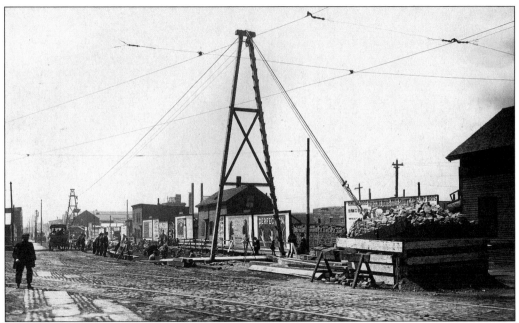

It is May 20, 1915, at the corner of Dorchester and Old Colony Avenues looking toward Andrew Square. Dorchester Avenue is torn up for subway construction. The crane-like device is a steam-powered cableway, similar to an aerial tramway, used to move construction materials between various worksites.

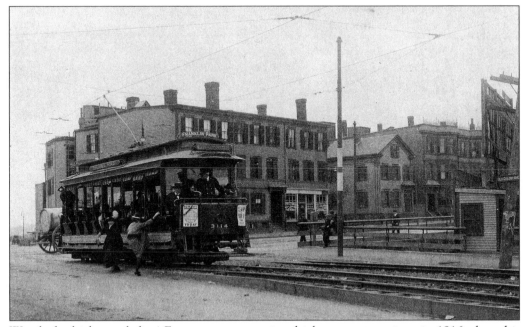

Watch the high step ladies! Easy access to transit vehicles was not an issue in 1916 when this open trolley bound for Franklin Park stopped for two lady passengers on Old Colony Avenue in South Boston. Temporary trolley tracks were laid atop the paving on Old Colony Avenue to divert the trolleys off of Dorchester Avenue to allow subway construction to proceed unhindered.

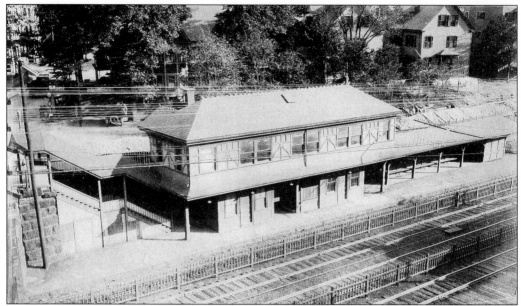

In the early 1920s, it was decided to extend the Cambridge to Dorchester Subway Line from Andrew Square to Ashmont and Mattapan. However, instead of an expensive subway it was decided to use the commuter rail tracks of the New Haven Railroad's Old Colony Division to reach Mattapan. Here is the station at Savin Hill on October 8, 1925, when it still served steam trains from Ashmont and Braintree.

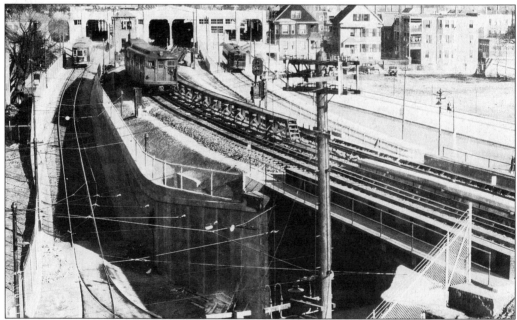

By November 14, 1927, when this photograph was taken, rapid transit service had been extended to the large new Field's Corner Station, which had replaced a small wooden railroad station on the same site. The new station provided easy transfer between rapid transit trains as well as buses and trolley cars serving many points in Dorchester. This station is now part of the MBTA Red Line.

Four

BOSTON IN MOTION

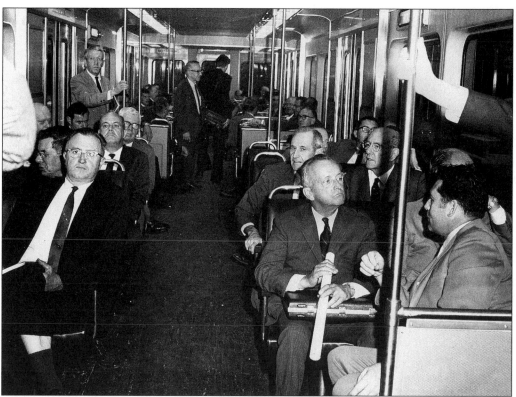

On September 25, 1969, the MBTA ran a publicity trip for local politicians, the press, and MBTA officials from Harvard to Ashmont and back followed by a buffet and cocktail hour at a Cambridge hotel. The comfortable forward-facing seats as seen in this view were later removed and placed in suburban commuter cars. They were replaced by long bench-type seats to allow more room for standees.

The long monopoly on cross-harbor transit enjoyed by the ferry lines was nearing its end as the ferry *Ben Franklin* was leaving the North Ferry Slip in Boston for East Boston. The workmen in the foreground were drilling the test borings for the East Boston Transit Tunnel, which opened in 1904, causing a severe drop in ridership on the ferries.

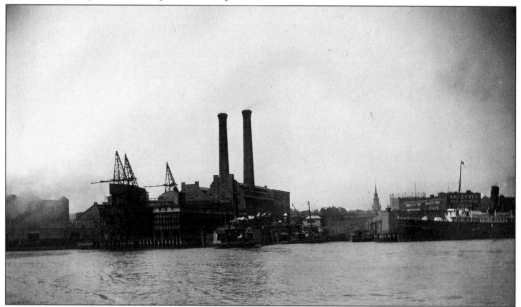

In this April 24, 1912 photograph the ferry *Noddle Island* leaving the North Ferry Slip for East Boston. The large building behind the ferry is Boston Elevated's Lincoln Power Station (now the San Marco Condominiums). The famous church steeple where the lanterns were hung for Paul Revere's ride is to the right, just above the bow of a Merchants & Miners Line steamer, which once connected Boston with other East Coast cities when coastal shipping was an important part of Boston commerce.

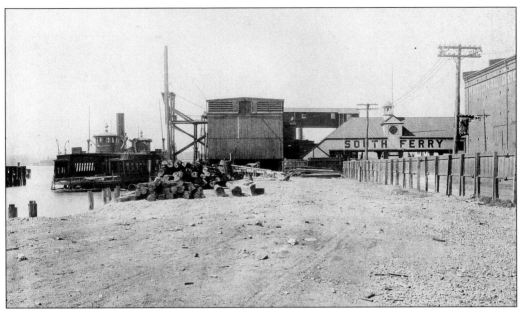

The East Boston Slip of the South Ferry Line was located at the foot of Lewis Street just a short distance from busy Maverick Square. In this rather quiet August 1924 view we see the ferry *John H. Sullivan* tied up to the maintenance dock that adjoined the South Ferry Slip.

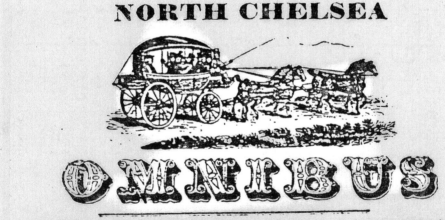

NORTH CHELSEA

OMNIBUS

LEAVES NORTH CHELSEA—At 7½ o'clock, A. M, and 1 1-2 and 6 o'clock, P. M.

LEAVES THE FERRY—At 8 1-4, o'clock, A. M. and 2 1-4 and 6 3-4, P. M.

FARE, 10 cents—12 tickets for $1 00. SLATE at Ferry Room, Jos. Fenno's and Jos

H. Fenno's. **WILLIAM FENNO.**

NORTH CHELSEA, July 16. 1849.

The fare was only 10¢ on the North Chelsea Omnibus Line, which ran from the Chelsea Ferry through Chelsea Square and into North Chelsea, which is now known as Revere. The omnibus line was run by William Fenno, a member of the influential Fenno family, who were also involved in local politics and the management of the Lynn & Boston Horse Railroad and the Boston, Revere Beach & Lynn Railroad.

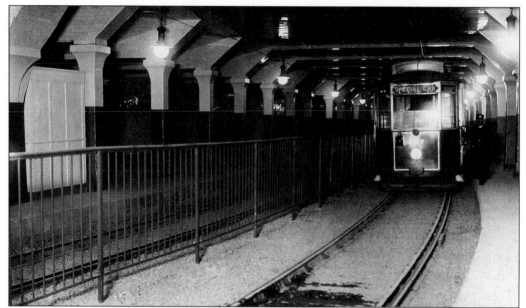

The Under Harbor East Boston Tunnel linking Scollay Square in downtown Boston with Maverick Square in East Boston opened on December 30, 1904. This view was taken on December 29 and shows one of the special cars run for employees of the Boston Elevated and the Boston Transit Commission and their families at the Devonshire Street Station, which is now known as State Street and is directly under the Old State House.

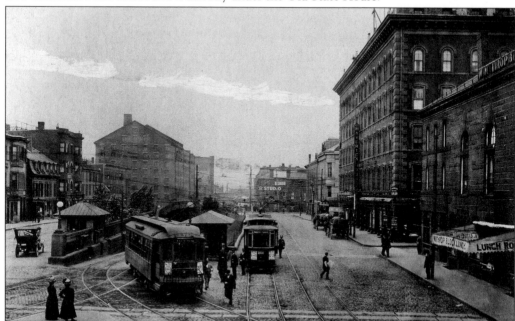

By 1908, when this view was made of the East Boston Tunnel entrance at Maverick Square, bigger and faster cars were used in order to handle the ever-growing crowds of riders. The South Ferry Slip can be seen looking straight down Lewis Street, while a shuttle car to the North Ferry awaits its departure. On the right is the Maverick House Hotel, which was built to serve the passengers of the Cunard Line's Boston to Liverpool Steamship Line.

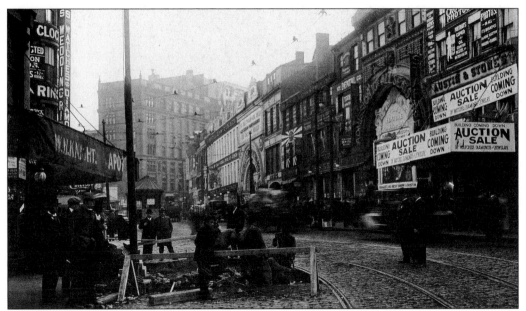

In 1912 it was decided to extend the East Boston Tunnel Line from its original terminal at Scollay Square on Court Street through Bowdoin Square and under Cambridge Street to North Russell Street. This would allow cars to operate directly from East Boston to Cambridge via downtown Boston and the Longfellow Bridge. Here we see the start of work at Hanover and Court Streets on the morning of November 29, 1912.

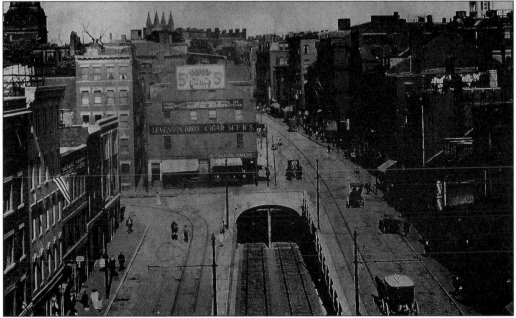

Cars from East Boston exited the tunnel at Cambridge and North Russell Streets, seen here on July 7, 1915, and proceeded to the Longfellow Bridge to reach Central Square in Cambridge. In later years Cambridge Street would be widened all the way to Bowdoin Square and the buildings in the center of this view would be razed. Note the Custom House Tower at the upper right—Boston's only "skyscraper" at this time.

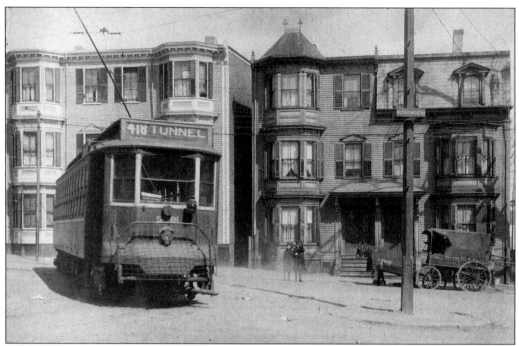

Against a backdrop of typical East Boston triple-deckers, a trolley prepares to leave Jeffries Point for Central Square in Cambridge via the East Boston Tunnel and Longfellow Bridge. It must have been cold when this 1915 photograph was taken as the two horses attached to the New England Telephone Company wagon have a winter blanket on.

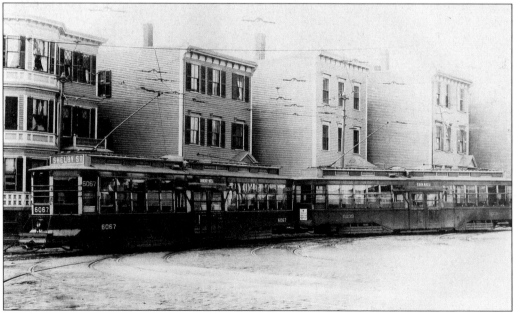

From 1917 until 1924 these large center door trolleys handled most of the traffic through the East Boston Tunnel. In April 1924 regular rapid transit trains replaced trolley cars in the tunnel. Cars of this type, seen here at the Eagle Street Car House in East Boston in 1918, continued to carry Green Line riders until 1952, when they were retired.

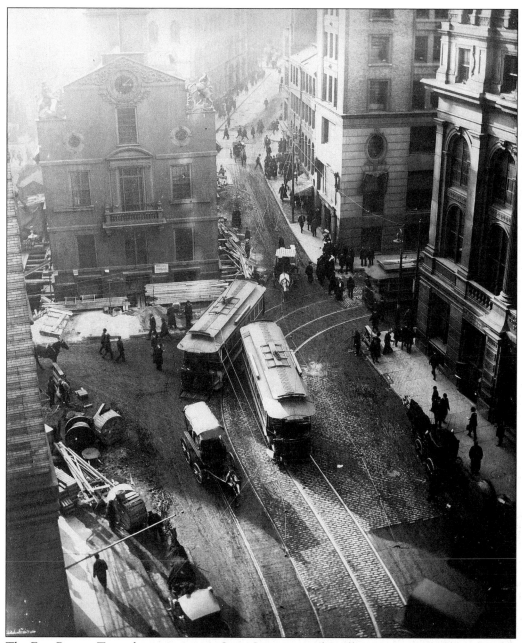

The East Boston Tunnel, in its route up State Street toward Scollay Square, passed beneath one of Boston's most historic structures—the Old State House, which was built in 1713. Because part of the basement of the building was taken for the Devonshire Street Station lobby, much care was exercised in shoring-up the building during construction, as can be seen here on March 6, 1903.

In 1924 the Boston Elevated and the Boston Transit Department converted the East Boston Tunnel from trolley car operation to third rail rapid transit, requiring passengers to transfer at Bowdoin and Maverick Squares to trolley cars to continue their trip. The Pullman Company of Chicago provided the cars for the changeover, one of which is seen here at the Eliot Square Rapid Transit Shop on December 3, 1923.

While the conversion of the East Boston Tunnel to train operation was a big improvement, it did not solve the problem of heavy trolley traffic on the narrow, often congested streets of East Boston, particularly Meridian and Bennington Streets. Here two trolleys pass on narrow Bennington Street, which has changed little since this 1928 photograph was taken looking toward Meridian Street.

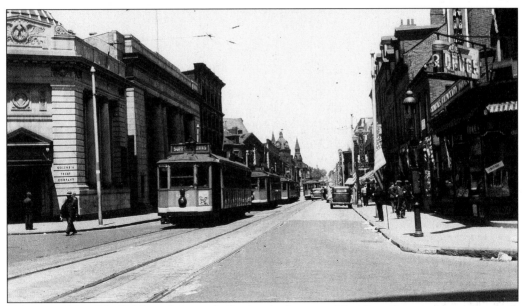

Taken on May 30, 1938, in Maverick Square looking up Meridian Street, this photograph shows the busy commercial street of East Boston with its usual parade of trolley traffic. Note the two handsome bank buildings on the left—the Columbia Trust Company on the corner next to the East Boston Savings Bank.

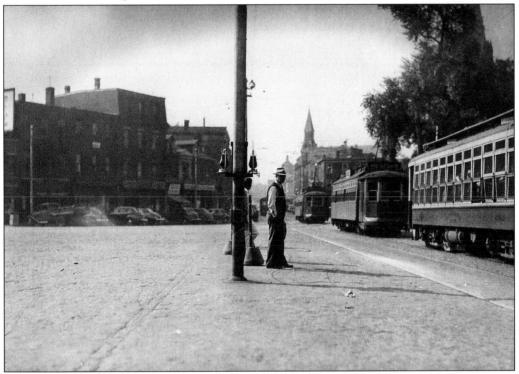

Standing in Central Square, East Boston, in the summer of 1942, we are looking toward Maverick Square. The trolleys are heading inbound to the Maverick Square Tunnel Station to pick up crowds of homeward-bound riders who lived in East Boston, Revere, and Chelsea.

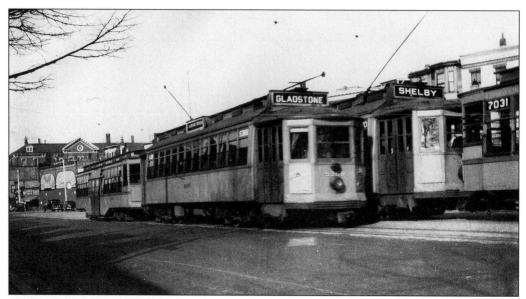

On March 30, 1936, Bennington Street at Day Square was devoid of auto traffic. The passing trolley trains had the street to themselves, allowing a fast ride for the passengers who paid the economical 10¢ fare, which entitled them to free transfer to the subway or other trolley routes.

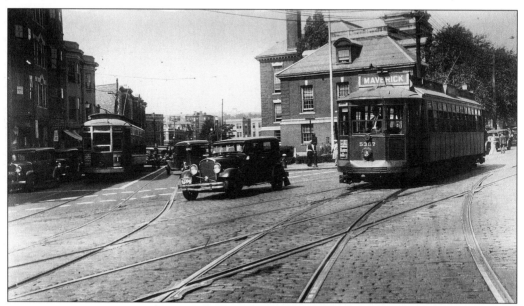

Bellingham Square in Chelsea was a busy trolley junction on July 19, 1934, when this photograph was taken. The Eastern Massachusetts Street Railway car on the left is en route from the Woodlawn section of Chelsea to Scollay Square in Boston via Charlestown, while the Boston Elevated car on the right is going to the Maverick Square Tunnel Station in East Boston.

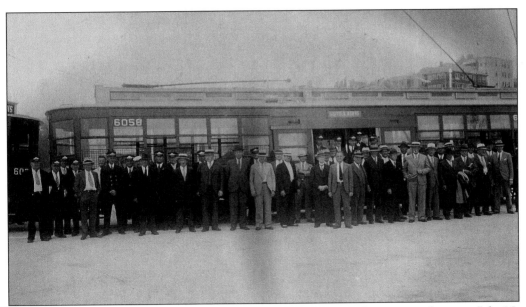

The opening of the Suffolk Downs Race Track on the Boston-Revere city line, on July 10, 1935, brought thousands of additional summer riders to the trolley lines serving East Boston and Revere, already crowded by beach-bound riders headed to Revere Beach for a day of sun and surf. Here is the first train into the racetrack on opening day. Boston Elevated trolleys carried 300,000 round-trip riders during the ten-day racing season.

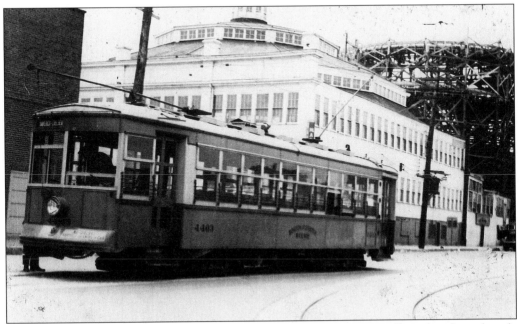

Boston's version of Coney Island was Revere Beach, with its excellent beach and wide assortment of amusements, rides, dance halls, and nightclubs offering something for every taste. Here we see a Maverick Square-bound trolley on Ocean Avenue, which ran parallel to the Revere Beach Parkway. The rear side of some of the amusement facilities, which fronted on the beach parkway, can be seen behind the trolley.

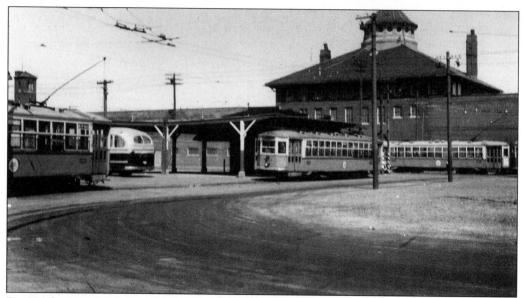

During the morning hours the Revere Beach Trolley Station was deserted since most riders left their cars a block or two away en route to the beach. By late afternoon the station would be jammed with homeward-bound riders, who had a choice of three trolley routes back to the Maverick Square Station. The large domed building in the background is the State Bath House.

This photograph was taken one late afternoon on Ocean Avenue, Homeward-bound beach-goers crowd aboard trolleys bound for the Maverick Square Tunnel Station and the subway ride into Boston after a day of surf, sand, hot dogs, and cotton candy. Some of these folks would need to get out the Pepto-Bismol when they got home!

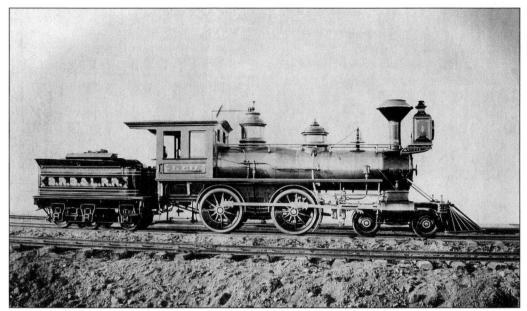

For many years prior to the extension of the MBTA Blue Line to Revere Beach, the Boston, Revere Beach, & Lynn Railroad served riders in East Boston and the Orient Heights, Beachmont, and Revere Beach areas. In its early steam days, trains were hauled by locomotives such as the *Leo*, built in 1876 by the Hinckley Locomotive Works on Albany Street in Boston's South End, now the site of an MBTA bus garage.

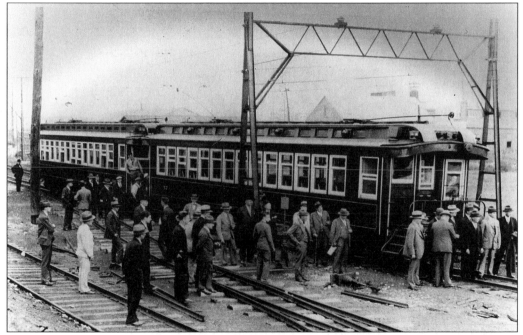

The Boston, Revere Beach, & Lynn Railroad converted from steam to electric operation in 1928. The first electric train is shown here on October 19, 1928, with officials of the General Electric Company and the railroad. The railroad went bankrupt and ceased operation in January 1940, but fortunately the right-of-way was preserved for future rapid transit operation.

Over a decade would elapse before the abandoned Boston, Revere Beach, & Lynn Railroad right-of-way would again see a train. In January of 1952, the East Boston Tunnel Line was extended to Orient Heights and further extended to Revere Beach in June 1954. Here we see one of the new trains built by the Saint Louis Car Company on a trial run on June 8, 1951.

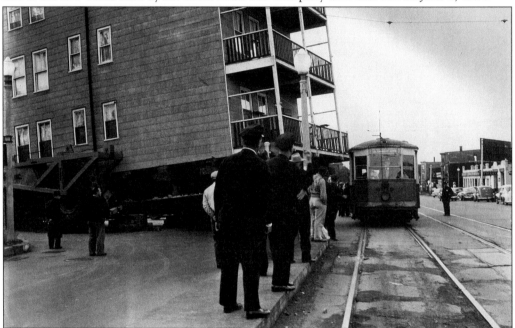

As part of the Revere Rapid Transit Extension Project, it was necessary that 26 one-, two-, and three-family houses be moved to new locations away from the path of the new rail line in the Wood Island section of East Boston. Each house was moved in less than a day to minimize disruption to residents. Here on July 13, 1950, a house and a trolley car slip past each other on Bennington Street.

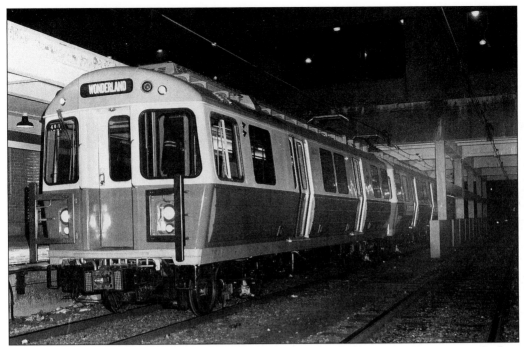

Riders on the East Boston Line, now the Blue Line of the MBTA, received a present of a fleet of modern, fast, air-conditioned cars in 1978. Here a train of the new cars is seen on an early morning test run at the Wood Island Station on November 20, 1978.

All trolley operations in East Boston and Revere were run from two car houses—Eagle Street in East Boston and Broadway in Revere. Here is a quiet moment at the car house in East Boston at Shelby and Eagle Streets, built in 1915 to replace the original 1894 buildings, which had burned down.

The car house on Broadway in Revere was built in 1910, replacing an earlier 1860s structure built by the Lynn & Boston Horse Railroad. This December 29, 1951 view was taken a few days before this car house was closed. A supermarket later occupied the site.

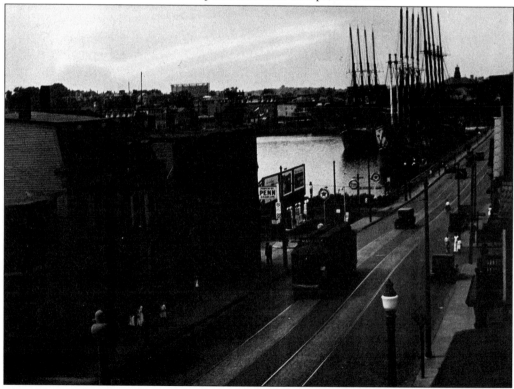

The sun was setting over Meridian Street at Falcon Street in East Boston when this photograph was taken in the summer of 1934. It had already set on the era symbolized by the four unused schooners tied-up in the background. The once-busy East Boston shipbuilding industry, which had spawned the famous clipper ships of Donald McKay, had by this time passed into history.

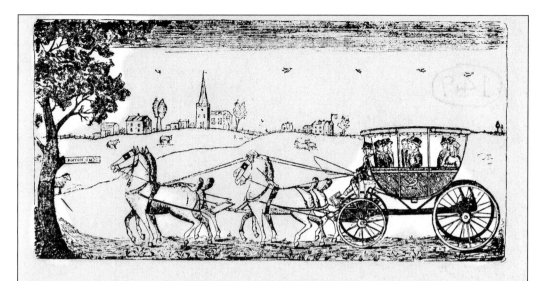

BOSTON,
Plymouth & Sandwich
MAIL STAGE,

CONTINUES TO RUN AS FOLLOWS :

LEAVES Boston every Tuesday, Thursday, and Saturday mornings at 5 o'clock, breakfast at Leonard's, Scituate ; dine at Bradford's, Plymouth ; and arrive in Sandwich the same evening. Leaves Sandwich every Monday, Wednesday and Friday mornings ; breakfast at Bradford's, Plymouth ; dine at Leonard's, Scituate, and arrive in Boston the same evening.

Passing through **Dorchester, Quincy, Wyemouth, Hingham, Scituate, Hanover, Pembroke, Duxbury, Kingston, Plymouth** to **Sandwich.** *Fare,* from Boston to Scituate, 1 doll. 25 cts. From Boston to Plymouth, 2 dolls. 50 cts. From Boston to Sandwich, 3 dolls. 63 cts.

N. B. Extra Carriages can be obtained of the proprietor's, at Boston and Plymouth, at short notice.— ☞STAGE BOOKS kept at Boyden's Market-square, Boston, and at Fessendon's, Plymouth.

Prior to the appearance of the steam railroad in 1834, travelers from Boston to outlying towns relied on the stagecoach. Here is the schedule for the Boston & Plymouth Coach Line for November 1810. Travelers were, as evidenced by the illustration of the riders bound for Plymouth, subjected to a tiring, day-long journey. With the opening of the Old Colony Railroad Line to Plymouth in November 1845, the trip time was reduced to two hours.

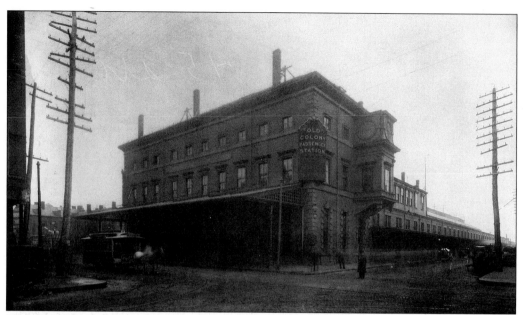

The Old Colony Railroad built its Boston Terminal on Kneeland Street at South Street in 1847. Due to the growth in traffic, it was remodeled and enlarged in 1867. Here is a view of the handsome terminal in 1892, with a South Boston-bound horse car passing by. This station was replaced by South Station in 1899.

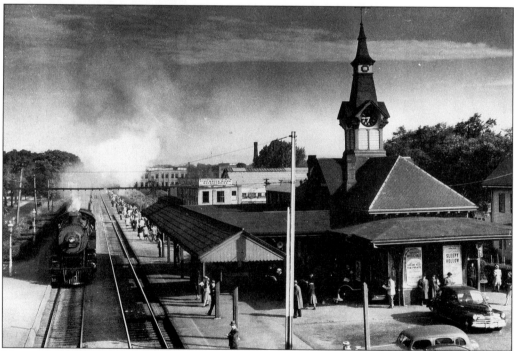

The picturesque Wollaston Station in Quincy is shown here at 6:45 a.m. in April of 1948, with the usual crowd of Boston-bound commuters awaiting their inbound train as an outbound train for Braintree and points south arrives. This section of the Old Colony was the most heavily used rail line in the Boston area.

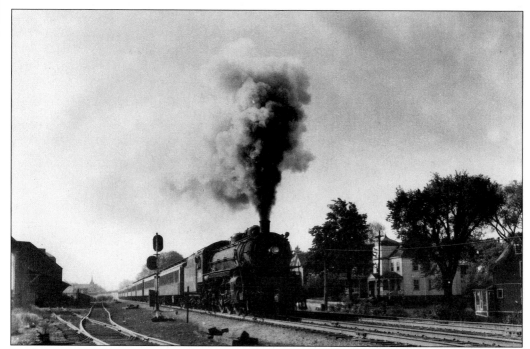

In this April 1948 scene, New Haven Railroad Locomotive 1305 is leaving Wollaston for Boston's South Station with a ten-car train on the Old Colony Division, which enjoyed a brisk freight business as well as heavy passenger traffic.

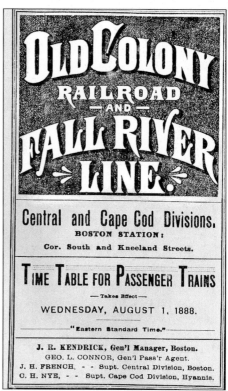

Prior to its acquisition by lease to the New Haven Railroad in 1893, the Old Colony Railroad operated a system of 600 miles of rail lines and 400 miles of steamship lines, including the famous Fall River Line, which ran luxurious steamers from Fall River to New York until 1938. Here is a system timetable cover for August 1, 1888.

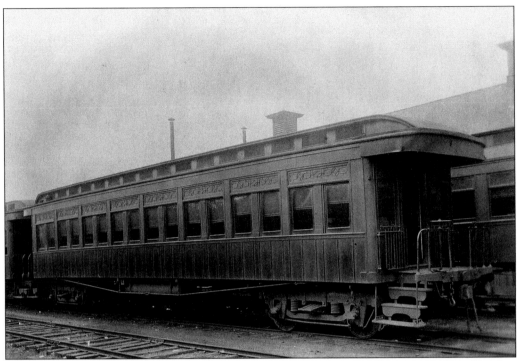

Typical of the coaches Old Colony passengers on local trains rode for many years is Number 216, built in the New Haven Railroad shops in 1883. The coach featured 61 plush seats, gas lights, and steam heat.

Today's Old Colony Division trains are among the nation's most modern and comfortable. The MBTA operates one of the nation's most extensive commuter rail systems.

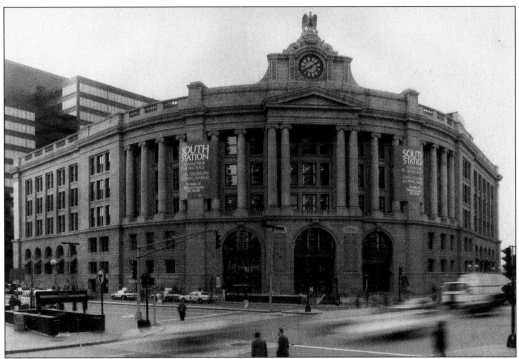

Looming impressively over Boston's Dewey Square is the handsomely rehabilitated South Station, which was for many years one of the nation's busiest rail terminals. After a narrow escape from the wrecking ball, South Station, now a century old, serves Amtrak and MBTA trains as well as Greyhound and other inter-city bus lines entering the heart of downtown Boston.

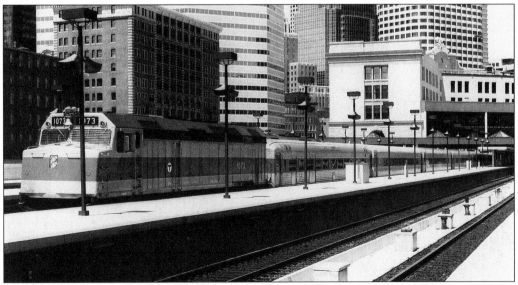

Behind the handsome turn-of-the-century facade of South Station is a modern inter-modal transit facility well suited to meet the needs of the city of Boston. Behind this commuter train leaving the station are examples of the early and modern types of architecture that make Boston such an interesting city.

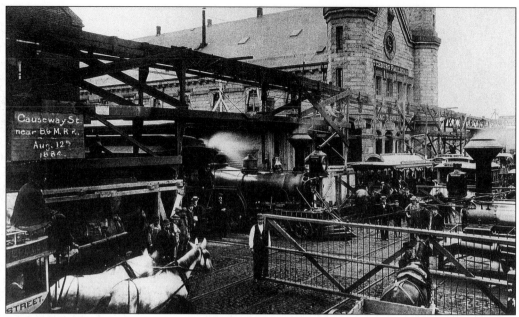

In this interesting view of Causeway Street taken on August 12, 1884, we see three forms of public transit—the steam railroad, the horse car, and the omnibus. The castle-like building is the Fitchburg Railroad Depot; the wooden trestlework running above the street carried a conveyor system used in the construction of the Metropolitan Sewer System.

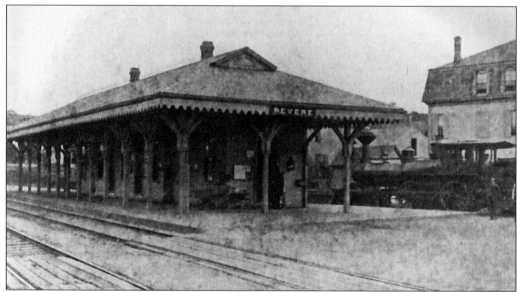

Revere at one time enjoyed commuter rail service on two railroads—the Eastern, absorbed into the Boston & Maine Railroad in December 1884, and the Boston, Revere Beach, & Lynn Railroad, which was abandoned in January 1940. Here is the old Revere Depot of the Eastern Railroad with Locomotive No. 14, built by the Taunton Locomotive Works, in 1847.

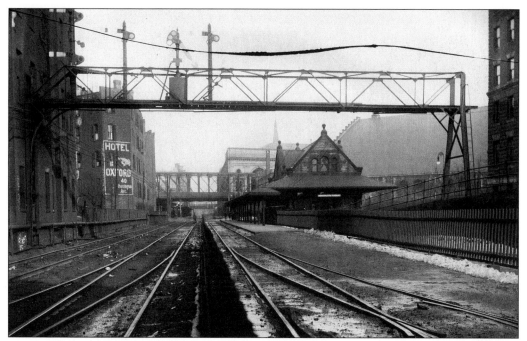

The Southwest Corridor, as it is now called, was always an important railroad artery. Here we are looking inbound toward Dartmouth Street in March 1908. On the right is the Huntington Avenue Station with the old Back Bay Station just beyond, while on the left, beyond the bridge, is Trinity Place Station. The new Back Bay Station replaced all three separate facilities in 1987.

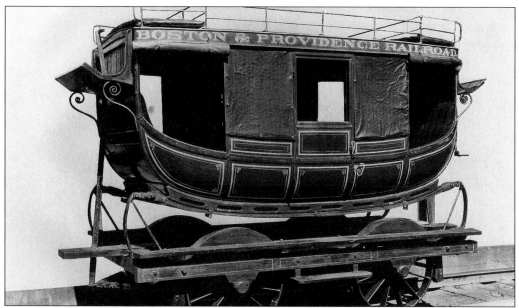

The Boston & Providence Railroad opened what was to develop into the Southwest Corridor on June 4, 1834, using primitive coach-like cars like the one seen here, which was hidden away in the back of the old Roxbury Crossing Railroad Shops and was restored for exhibition in 1891. It is now on display at the Saint Louis Museum of Transportation.

Looking outbound toward Dartmouth Street we see the new Back Bay Station, which serves Amtrak, MBTA trains, the Orange Line Subway, and local buses. This October 1987 view gives a good example of the remarkable growth in Boston's Back Bay.

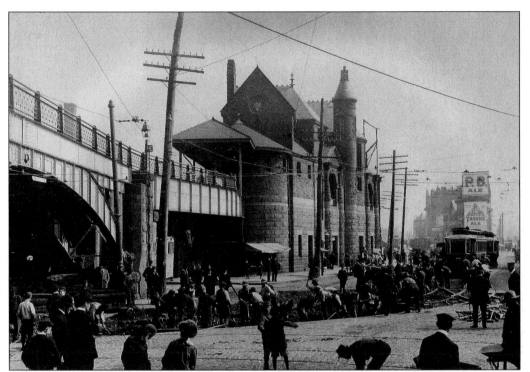

Here is Roxbury Crossing looking inbound at Columbus Avenue and Tremont Street with the raised Roxbury Crossing Station (center). In the foreground, a crew is repairing the trolley tracks at what was a busy transit junction when this view was taken on May 4, 1906.

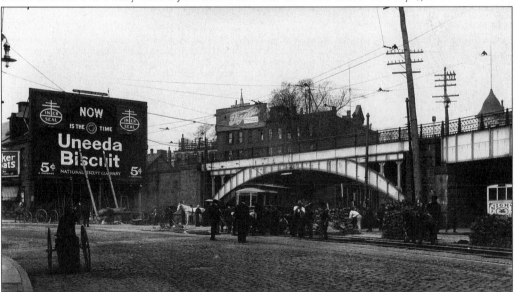

It is still May 4, 1906, at Roxbury Crossing but we are looking outbound with Tremont Street bending to the right under the railroad embankment. The Roxbury Crossing Car House advertising Uneeda Biscuits is at the left. Note the horse-drawn all-night lunch wagon under the bridge to the right, once a common sight around Boston. This area has since been changed beyond recognition.

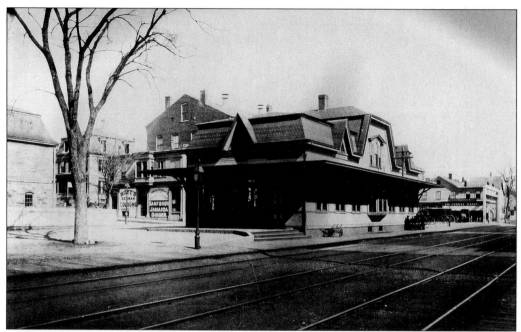

In this 1872 view of what became the Southwest Corridor, we see the Jamaica Plain Station Building that was built in 1871 to replace an earlier structure. Note that the surface-level right-of-way has only three tracks; the fourth track was added when the grade was elevated in the mid-1890s.

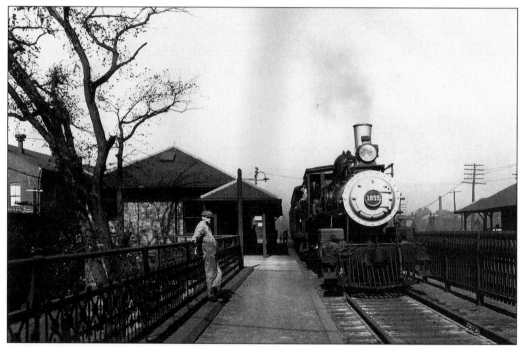

In this 1909 view a local Forest Hills to Boston train stops at the Jamaica Plain Station. This brick station was built in 1893 and 1894 as part of the grade elevation project. The present station on this site is called Green Street and is served by Orange Line trains.

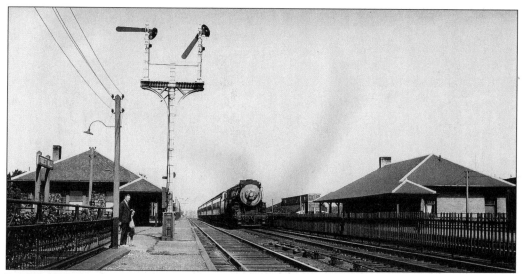

In this view on September 23, 1933, the New York-bound *Yankee Clipper* is seen speeding through the Forest Hills Station. Only a few local trains stopped at Forest Hills at this time and the station was closed to the public for good on September 30, 1940.

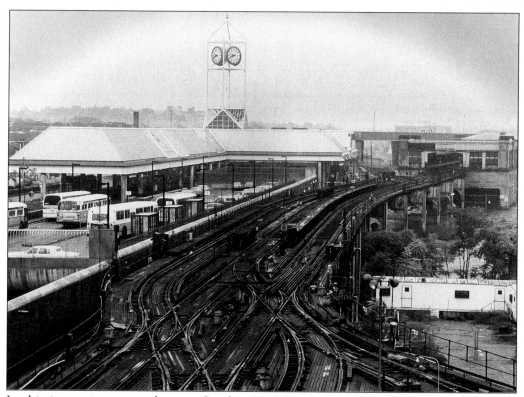

In this interesting view taken on October 19, 1987, both the recently closed Forest Hills Elevated Station (right) and the new Forest Hills Orange Line Station (left), which stands on the site of the old Forest Hills Railroad Station, are visible. Shortly after this photograph was taken, the old station and the elevated structure were demolished.

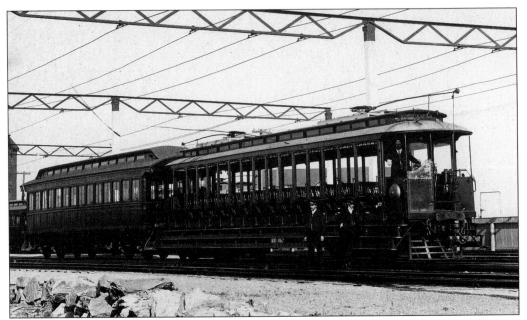

From the mid-1890s up to World War I, the railroads serving Boston gave serious consideration to the electrification of their commuter rail lines and some trial installations were made. Here is a New Haven Railroad electric train at Pemberton, MA, on the Nantasket Beach Branch, which connected with the Old Colony Division at Braintree Junction.

The Boston & Albany Railroad considered converting its commuter lines from Boston to Riverside, via both the Main Line and the Highland Branch, to electric operation and converted the short Newton Lower Falls to Riverside Line as a trial. It was nicknamed the "Ping-Pong" Line because the electric car seen here at Newton Lower Falls simply bounced back and forth between the two terminals of the short route.

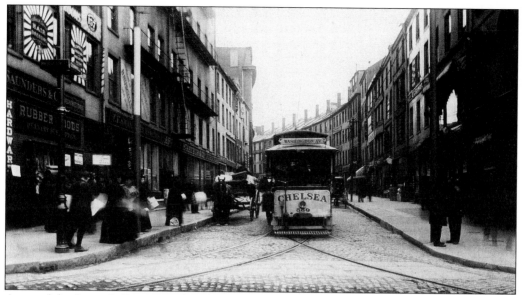

A car of the Lynn & Boston Railroad Company bound for Washington Avenue in Chelsea is shown here on Cornhill Street in Boston on April 14, 1897. As the result of an intensive series of leases and acquisitions, the Lynn & Boston evolved into the huge Bay State Street Railway, which not only served all of Eastern Massachusetts but portions of New Hampshire and Rhode Island as well. As the result of a bankruptcy, the company became the Eastern Massachusetts Street Railway Company on June 1, 1919.

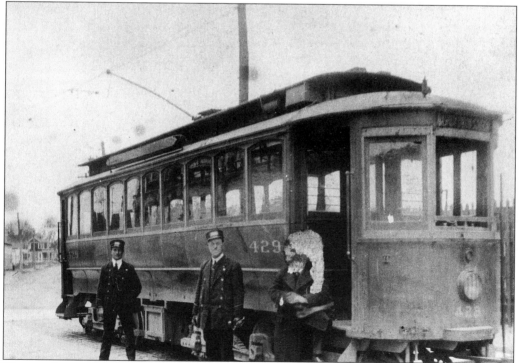

The northernmost area served by the Bay State system was Nashua, NH. Here we see a Bay State Car on the Lake Street-Union Station Line, *c.* 1915.

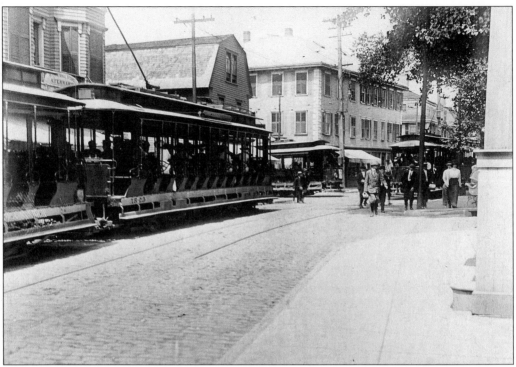

The southernmost point reached by the big Bay State system was the resort town of Newport, RI. In this 1915 scene, we see a group of Bay State Open Trolleys at Spring and Franklin Streets in Newport, where the summer tourist traffic was quite heavy.

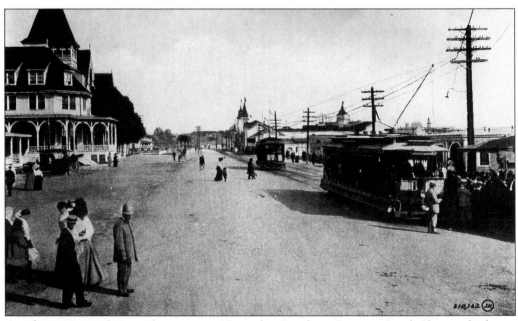

Another very popular seaside resort was Nantasket Beach on Boston's South Shore, which was also served by the Bay State Street Railway, the Old Colony Railroad, and the Nantasket Steamship Company. This view was taken in 1910.

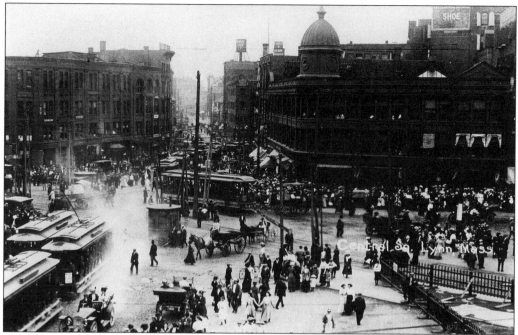

One of the busiest divisions on the Bay State system was Lynn, where trolley routes from Boston, Chelsea, Salem, Swampscot, and Saugus all converged, in addition to the local city routes. Here is Central Square in Lynn in 1915, prior to the elevation of the Boston & Maine Railroad tracks through the downtown area.

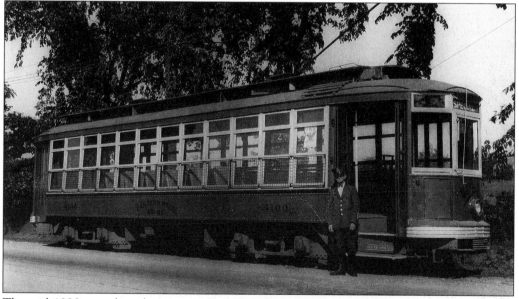

The mid-1930s saw the substitution of buses in place of trolleys on many routes of the far-flung Eastern Massachusetts Street Railway, especially on the long cross-country suburban routes. Here, on June 16, 1935, is the last electric car to travel over the line from Salem to Lawrence. The car was being transferred from Revere to Haverhill, where it would finish out its passenger-carrying days.

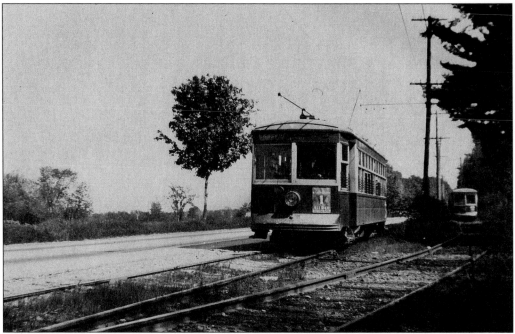

On May 26, 1935, two Eastern Massachusetts Street Railway trolleys passed one another at Farnham Siding in North Andover on the long Salem-Lawrence Line. The construction of good roads and the low population density in areas such as this, plus the economic depression of the 1930s, were contributing factors to the demise of trolley cars on these long routes through rural areas.

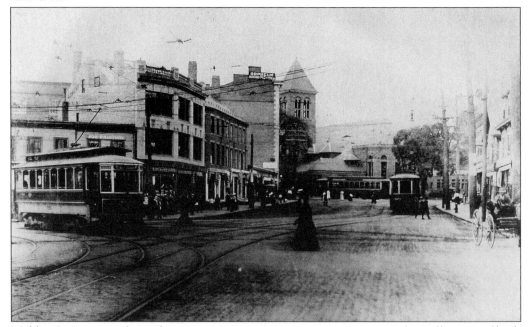

Malden Square was a busy place c. 1914, as it was a major junction point for trolley cars of both the Boston Elevated and Bay State systems. A number of the buildings in this view are still standing.

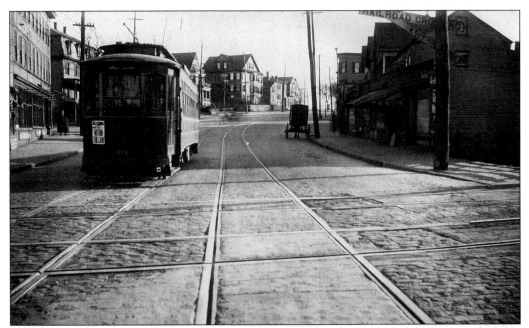

En route to Lowell, via Reading from the Sullivan Square Terminal, is this Bay State Street Railway Car pausing at the Boston & Maine Railroad Crossing on Main Street in Malden; Buses replaced trolleys on this route on May 24, 1931.

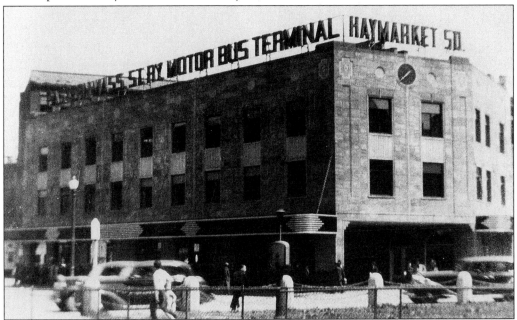

By the summer of 1935, the Eastern Massachusetts Street Railway had become mostly a bus operation, with trolleys left only on a few heavy routes. In 1935 the company erected a handsome modern bus terminal in Haymarket Square in Boston. The first floor was devoted to bus lanes, ticket tellers, and waiting rooms with the company offices on the upper floors. Sheathed in a bright tan stone with red neon signs, the terminal was torn down in 1955, a victim of the construction of the Fitzgerald Expressway.

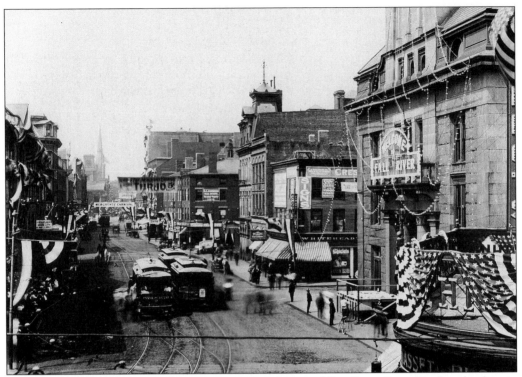

This view is Main Street in Fall River, c. 1910, with several Bay State Open Trolleys loading in front of the old city hall. This area is now totally unrecognizable; nearly everything in this view was demolished to make way for Interstate 195, which slashed its way across downtown Fall River.

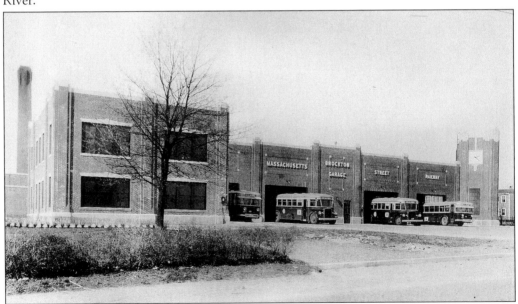

The Eastern Massachusetts Street Railway was noted for its well-designed bus garages and terminal buildings. Here is the Brockton Division Garage on Torrey Street in that city. This view was made in 1936 and the building survives virtually unchanged as a department store.

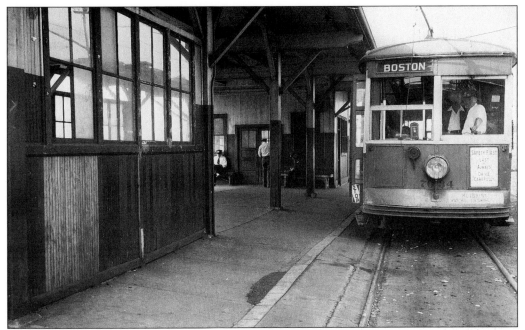

The last city to be served by Eastern Massachusetts Street Railway trolleys was Quincy, MA, where three trolley routes survived until after World War II. One of these routes operated to the Field's Corner Red Line Station in Dorchester from Quincy Square. Here is a car at the Neponset Station in Dorchester, where a Boston Elevated operator would take the car for the remainder of the trip to Field's Corner.

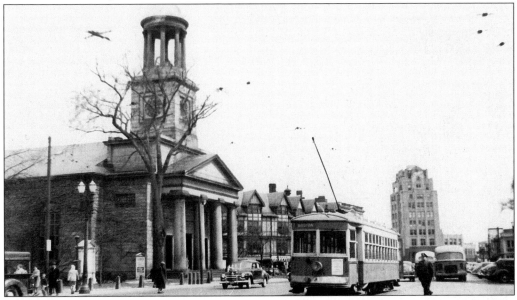

The Eastern Massachusetts replaced its last trolleys in Quincy with buses on May 1, 1948. Here is a car on the final day of trolley operation in Quincy Square with the historic Granite Church on the left and the office tower of the former Granite Trust Company in the background. At this time, the Eastern Massachusetts was New England's largest bus system, operating over 1,000 buses.

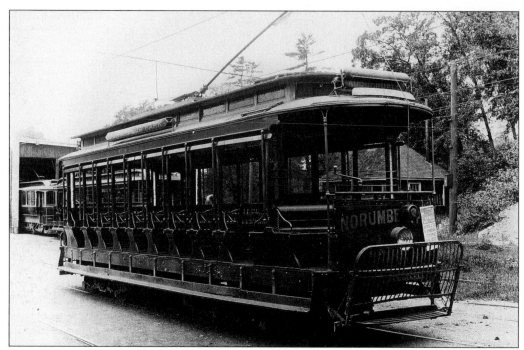

A transit company that played a rather secondary roll in Boston's transportation system was the Middlesex & Boston Street Railway Company, which served several suburbs to the west of Boston. Here is one of that company's open trolleys at the Auburndale Car House. For many years this company operated Norumbega Park in Newton, one of New England's favorite amusement parks and ballrooms.

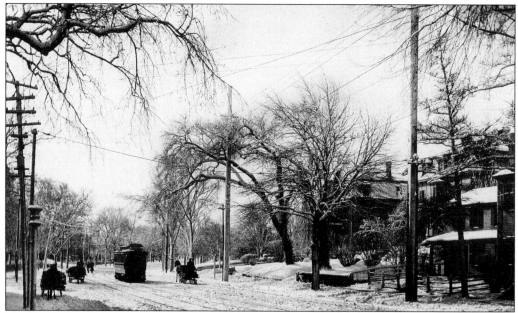

This Christmas card scene is North Avenue (now Massachusetts Avenue) in Cambridge, just north of Porter Square during the winter of 1891 and 1892. The Arlington Heights-bound trolley has the street all to itself except for the three sleighs and two pedestrians.

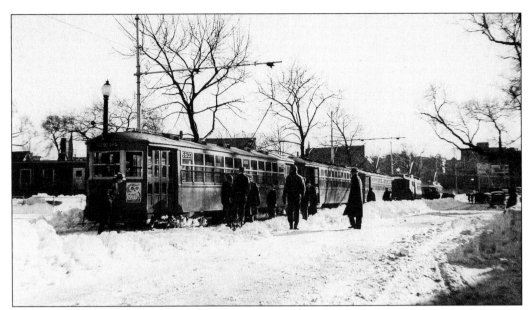

Snow could at times become a problem for transit systems when it fell in great quantities, as it did on Saint Valentine's Day in 1940. Here we see the trolley line at Columbia Road in Upham's Corner being reopened after a major snowstorm.

Here we have a similar scene on Saint Valentine's Day, but on Centre Street in Jamaica Plain, where even the snowplow got bogged down behind a stalled passenger trolley.

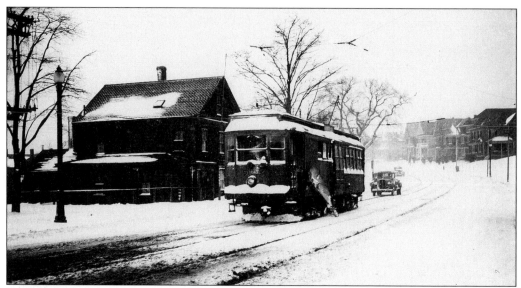

One of Boston Elevated's versatile "Number 3"-type snow plows moves along Centre Street in West Roxbury, sprinkling salt on the street in the early stage of a 1923 snowfall.

Without a snowflake in sight, one of the big Type 3 trolley plows sits in the sun at the Arborway Car House in March 1948. Built as passenger cars in 1907, these rugged cars were converted into snowplows in 1930. The MBTA still has several of these cars, now nearly a century old, in use as snowplows and tow cars.

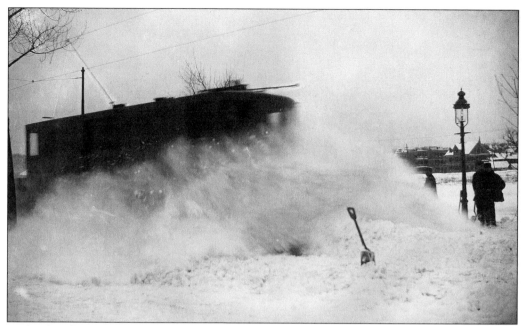

In the days before too many automobiles clogged streets in stormy weather slowing movement down, the big trolley plows were able to perform to their full capabilities. Here a snowplow tackles a drift on the Fellsway Line in Medford in March 1916.

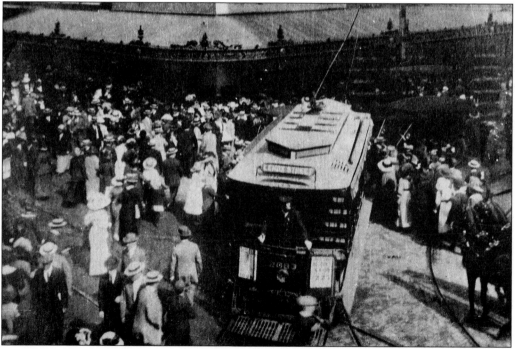

An open trolley headed for Lenox Street in Roxbury crawls through a throng of pedestrians as it moves from Summer Street onto Washington Street at what was then called Boston's busiest corner, now referred to as Downtown Crossing. The recently built Filene's Department Store is visible in this 1914 photograph.

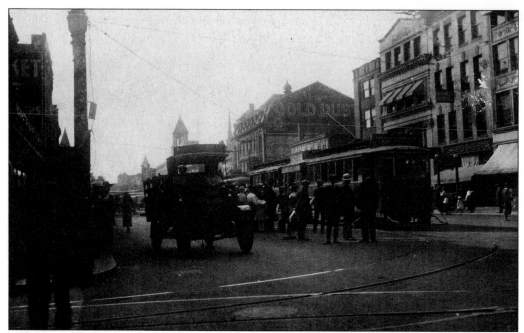

Central Square in Cambridge was a busy place when this early 1920s photograph was taken looking toward Harvard Square. An early type of articulated trolley or "Snake Car," as they were called by the riders, is loading passengers for Union Square in Somerville as a long-vanished make of motor truck—a Selden—passes by.

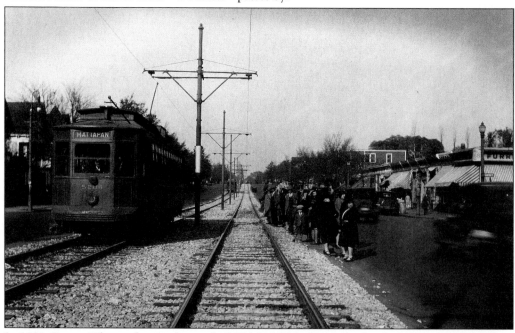

In 1929, Boston Elevated carried a total of 354,214,990 passengers for the year, or an average of 1,049,304 riders per day. Making a major contribution to that total was the busy Mattapan-Blue Hill Avenue Line, where cars ran every 90 seconds at peak periods. This view is at Blue Hill Avenue and Arbutus Street on October 21, 1929, at 2:00 p.m.

Not all lines were as busy as the Blue Hill Avenue Line. Some short suburban lines saw crowded cars only during peak rush hours. One such line was the short Grove Street Shuttle in West Roxbury, where the operator had time to pose with a proud parent.

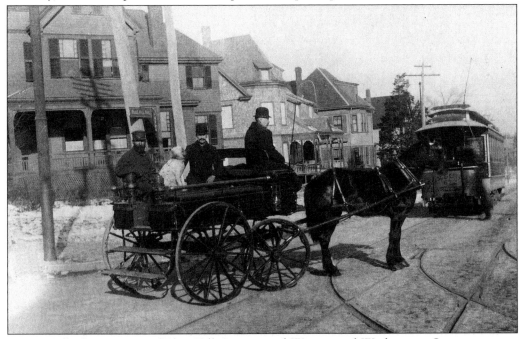

Grove Hall, the junction of Blue Hill Avenue and Warren and Washington Streets, was not always the busy square it became in later years. In this 1893 view, we are looking down Blue Hill Avenue as a trolley arrives from Sullivan Square in Charlestown. There is no explanation for the horse-drawn rig standing on the car tracks.

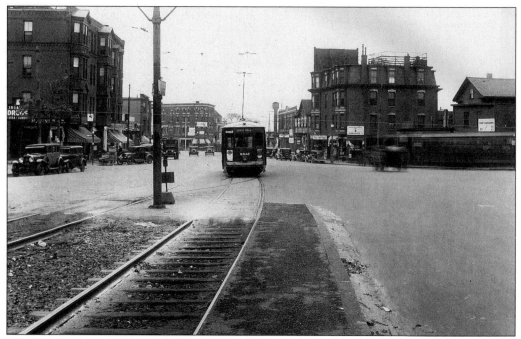

After 1900, Grove Hall rapidly developed into a thriving commercial center and busy trolley car junction where four routes met. The trolley in the center is headed for the Dudley Street Elevated Station, where passengers would board El trains for downtown Boston.

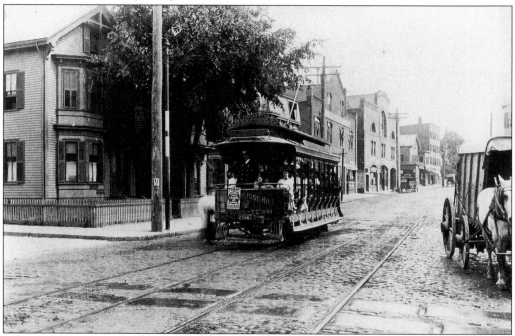

It is August 23, 1907, and this cross-town trolley from Meeting House Hill in Dorchester is rolling along Dudley Street bound for the Dudley Street Elevated Station and beyond to Roxbury Crossing. The two brick buildings to the rear of the trolley were the old Mount Pleasant Car Barns, which had been converted to a laundry.

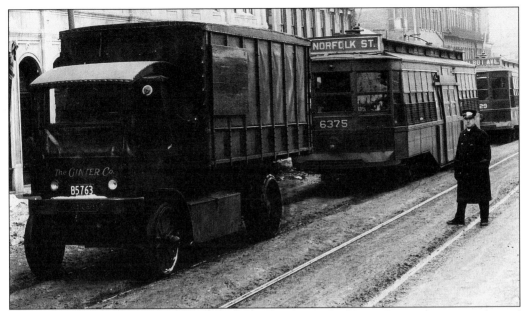

This 1923 view on Warren Street in Roxbury was taken to dramatize a problem that confronted Boston Elevated every winter—trolley cars delayed by delivery trucks standing on the tracks due to poor snow removal by the city. The Ginter Grocery Chain, who ran a large number of markets in the Boston area, owned the Walker Electric battery-powered truck delaying the trolleys.

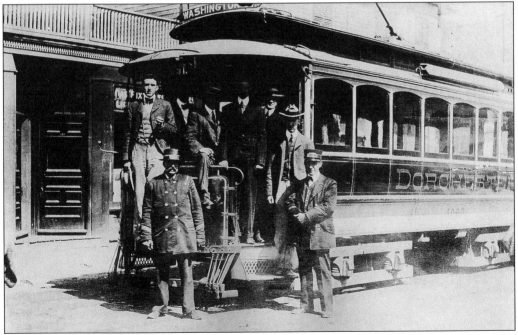

"Never mind the schedule, we're getting our picture taken!" seems to be the attitude of the trolley car posing with some well-dressed dandies at the end of the Norfolk Street Line in Dorchester. Eventually, the car would depart for Washington and Franklin Streets in downtown Boston. The view dates from 1895.

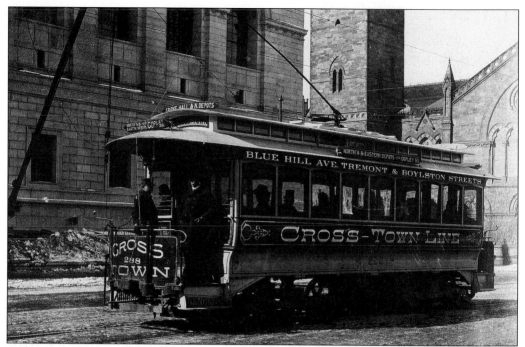

In this 1892 view in Copley Square, we see a cross-town trolley on the long route from Grove Hall to the North Station via Copley Square and Tremont Streets. In the background, McKim's handsome Boston Public Library is under construction while on the right is the "new" Old South Church, built in 1874.

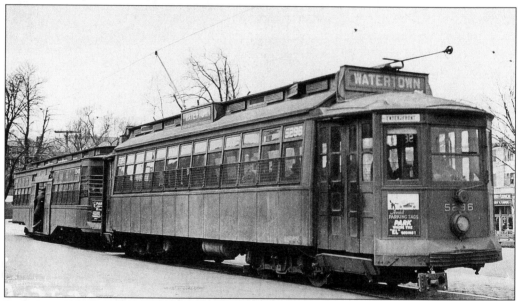

In the period between the two world wars, trolley trains like this one carried Boston-area transit passengers to work, school, the beach, and holiday outings. The train is shown here at Oak Square on the Watertown-Park Street Subway Line, a portion of the Green Line abandoned by the MBTA in June 1969 in order to divert riders away from the busy Green Line Subway system.

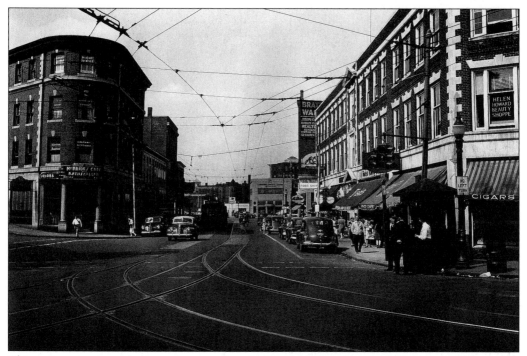

This quiet morning photograph was taken in Harvard Square, at 10:30 a.m. on August 24, 1946, as a train of center door trolleys approach along Brattle Street from the Bennett Street Car Barns. The first floor of the building (left), occupied by the Rathskeller, has seen many tenants since this photograph was taken, including a Howard Johnson's restaurant and a bank.

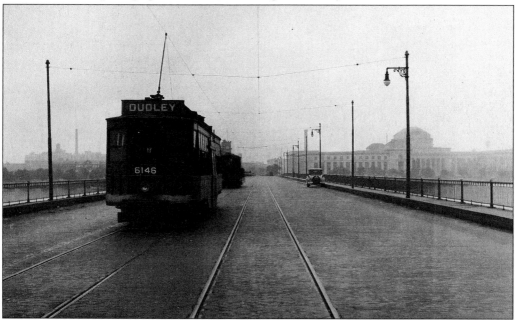

This foggy morning on the Charles River occurred in 1929 on the Massachusetts Avenue Bridge. A center entrance trolley on the Harvard Square-Dudley Station Line is approaching; buildings of the Massachusetts Institute of Technology are visible on the right.

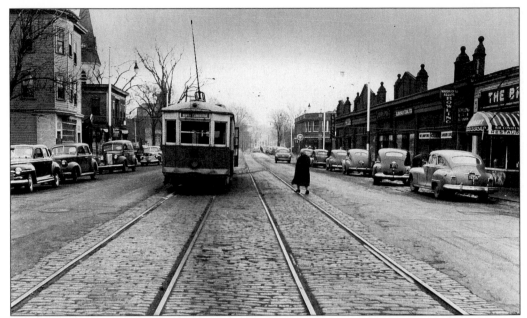

At Waverly Square in the mid-1940s, the trolley in the foreground departed for Harvard Square and beyond, to North Cambridge. The Waverly Square Business District was typical of neighborhood commercial centers of the mid-1940s.

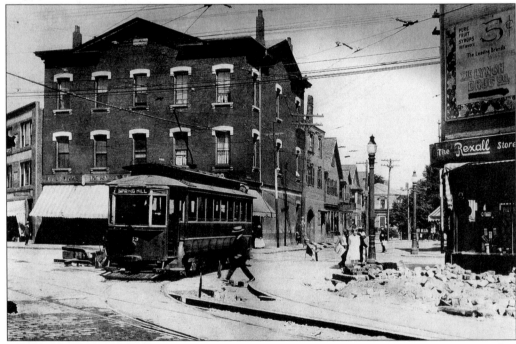

The corner of Hampshire and Springfield Streets in Cambridge is shown here with a trolley heading for Spring Hill in Somerville. Several vanished vignettes beside the trolley appear in this view, including the piles of Belgian Blocks used for street paving, the newsboy with his bundle of papers, and the Rexall Drug Store, once a leading drug chain with headquarters in Boston.

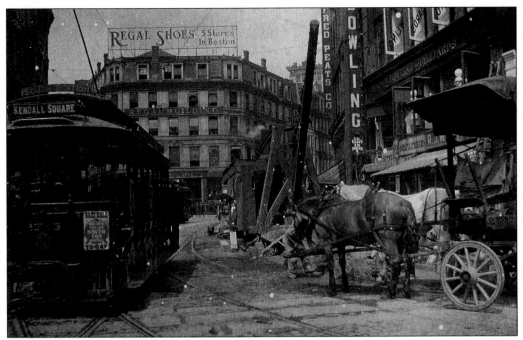

A trolley bound from South Station in Boston to Kendall Square in Cambridge rolls along Summer Street at Church Green in downtown Boston, 1914. The construction was for an extension of the Cambridge Subway from Harvard Square and Park Street to South Station, which replaced the trolley route. The head office of the Regal Shoe Company is visible ahead of the trolley. Regal Shoe was once a major local shoe manufacturing and retail firm in the Boston area.

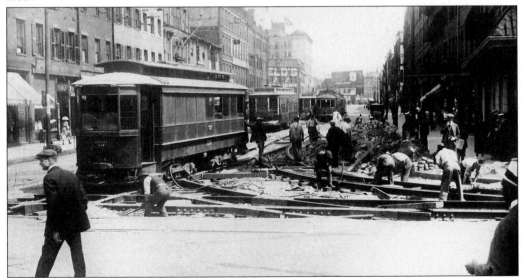

As trolley cars became larger and heavier, the wear and tear on rails of busy routes required increased maintenance. In this July 1920 photograph, we see workmen replacing curves and switches at Tremont and Dover Streets in Boston's South End. The trolley car in the foreground was an air compressor car that supplied air for the pneumatic tolls used by the workmen.

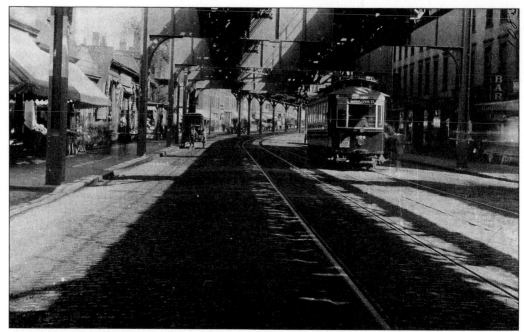

Washington Street is shown here in 1914, looking from Dover Street, with a trolley on the Park Street Subway-Washington Street Line rolling along under the Forest Hills Elevated Line. Both the Elevated and the Trolley Line are long gone and the 1980 MBTA promises to restore the Washington Street Trolley Line to replace the Elevated have yet to be kept. An infrequent bus service now serves this heavily populated area.

Here is Massachusetts Avenue at Commonwealth Avenue on a chilly February 17, 1924, with a policeman directing rather light traffic, including a trolley on the Harvard Square-Dudley Station Line. In later years, an underpass would carry Commonwealth Avenue traffic beneath Massachusetts Avenue. Most of the interesting buildings in this view are still intact.

Traffic is virtually non-existent in this view of Massachusetts Avenue looking toward Symphony Hall from Commonwealth Avenue. A large and busy crew is replacing worn trolley rail as an open trolley on the Harvard Square-Dudley Station Line passes by.

Here is Summer Street in downtown Boston at Arch Street on the afternoon of July 8, 1912, with a trolley en route from Harvard Square to South Station. The Filene's Department Store building was still new, while the popular Kennedy's Clothing Store nearby would last until the early 1960s, when both the store and a portion of the building would vanish. Within a few months of this view, Summer Street would be excavated to extend the Cambridge-Park Street Subway to South Station.

In this late 1890s view of Bowdoin Square, a trolley on the South and West End's Belt Line is vanishing up a side street from a square devoid of traffic. It looks almost bucolic with the blooming trees in front of the remaining private residences, which would soon make way for commercial activity.

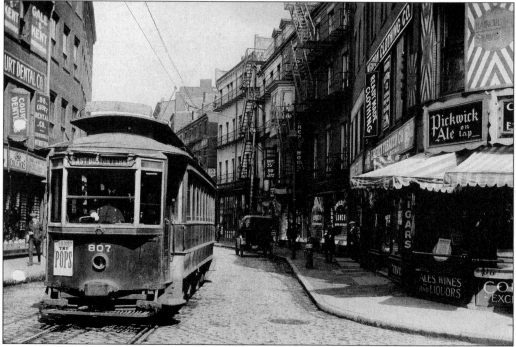

Here is Court Street in Boston in 1919, lined with small businesses and retail establishments along with small hotels and rooming houses. Typical of this section of Boston is the use of red brick for the buildings and sidewalks while the street paving is Belgian Block. The trolley just left Scollay Square and is bound for the East Boston Ferry Slip.

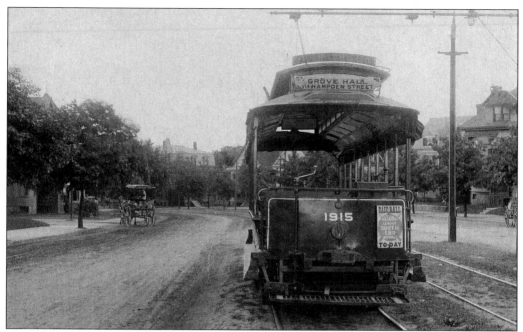

Columbia Road in Dorchester was once a handsome boulevard lined with trees and with a wide center reservation with trolley tracks and trees. Here is a view of Columbia Road looking from Blue Hill Avenue in October 1914, when it was lined with fine homes. The trolley was not in regular service when the Boston Elevated's photographer took this photograph.

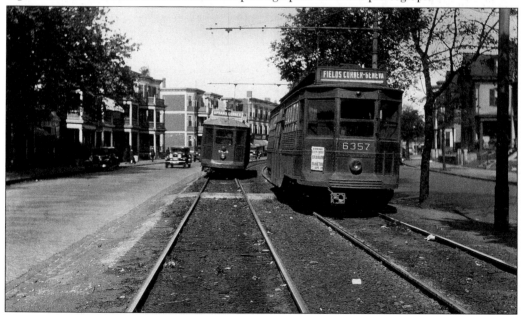

Here is another view of Columbia Road just south of Edward Everett Square taken in September 1929. In 1949 the reservation, trolley tracks, trees, and the rest were replaced by a wide, brightly lighted highway with a concrete center island, which quickly generated a great deal of noisy, polluting traffic. Real estate values fell as residents moved away and a period of decay followed.

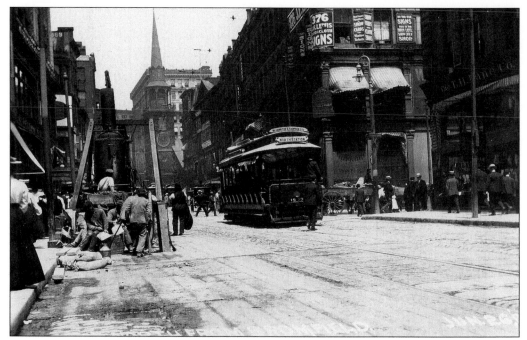

One of the more difficult subway construction projects in Boston was the construction of the Washington Street Tunnel from the South End to Haymarket Square. Here is a view of Washington Street looking north from Bromfield Street toward the Old South Church. Note the wood planking covering the excavation to minimize traffic disruption.

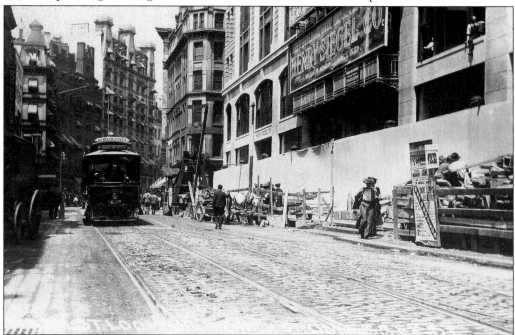

Here is narrow Washington Street during the construction of the subway on June 26, 1905, with a trolley en route to Codman Square and Meeting House Hill in Dorchester. Clark's Hotel and the Adams House are on the left in this view looking north from Essex Street.

This July 11, 1927 photograph is looking south along the Old Colony Railroad in Dorchester from what is now the J.F.K.-U.Mass Station on the Red Line, which is under construction in this view. On the right is the soon to close Crescent Avenue Railroad Station. The overpass for the Southeast Expressway crosses the Red Line at this point and the south end of the Organ Factory Building was demolished in 1958 to make way for the Expressway.

While a variety of cars once ran in Boston-area streets, one of the most common and widely remembered among older Bostonians is the "Type Five" car. Nearly 500 of these durable, if noisy, cars carried generations of Bostonians from 1922 until the last few were retired in 1959. Here is a freshly painted Type Five at the Everett Shops of the Boston Elevated on April 10, 1945.

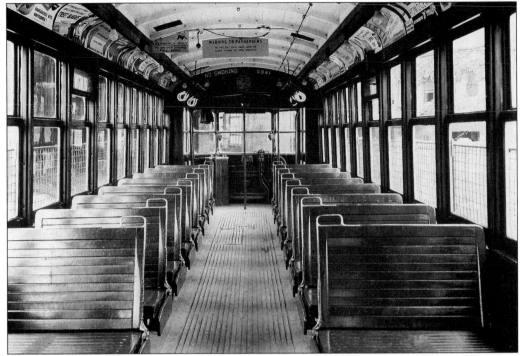

While the interior decor of the Boston Elevated's Type Five cars was rather spartan, the cars provided basic efficient transportation, were warm in the winter, and were cool in the summer, since all the windows opened to admit the summer breeze. With wide aisles and spacious end vestibules, there was always room for one more passenger during the busy rush hours, when up to 150 people would be squeezed aboard.

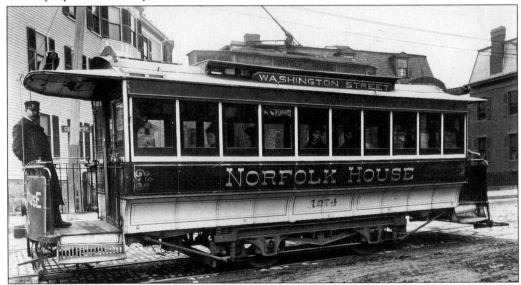

While Boston's early trolleys provided soft plush seats for riders, they were not heated. The motorman and conductor had to endure the rigors of winter on the open end platforms of the cars until a state law was enacted in 1901 requiring the ends of the cars to be enclosed. This trolley is about to leave the Norfolk House in Roxbury for downtown Boston in 1895.

In June of 1950 a Naval Task Force, including the battleship *Missouri*, docked at the Boston Navy Yard for servicing. The MTA provided special buses to carry hundreds of Navy men to a Red Sox-Detroit Tigers game at Fenway Park. Here we see the buses at dockside at the navy yard.

With the famous battleship *Missouri* at left and an aircraft carrier in the distance, special MTA buses awaited the crowd of sailors they carried to Fenway Park for a Red Sox-Detroit Tigers game. Boston was a favorite port of call for United States Navy men.

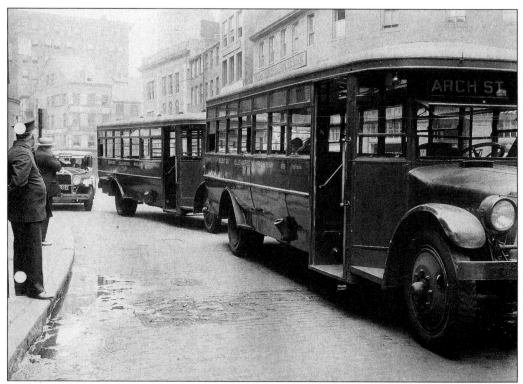

In the summer of 1933 these Boston Elevated buses stood on High Street at the corner of Atlantic Avenue, across from Rowe's Wharf awaiting the usual crowds who arrived on the steamers from Nantasket Beach and ferry boats of the Boston, Revere Beach, & Lynn Railroad.

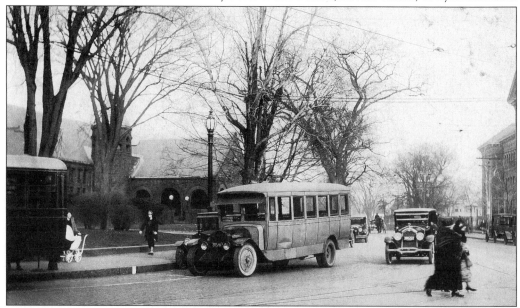

Many suburban areas of Boston had feeder service provided by small, locally owned bus companies. Here we see a Hart Bus at Malden Square in 1924. This bus was operated on a route from Malden to Cliftondale and Saugus.

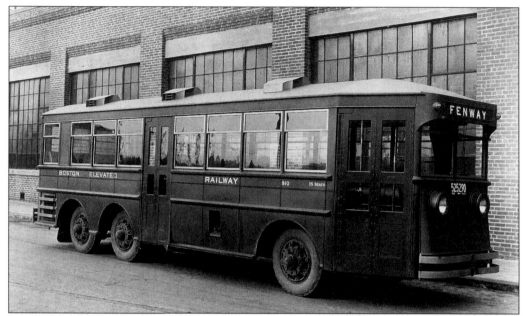

In this May 1928 scene at the Allston Garage of the Boston Elevated we see a Vesare six-wheeled gas-electric bus. Buses of this type served Allston, Brighton, and sections of Dorchester for a number of years. The Vesare Company was a subsidiary of the Cincinnati Car Company, one of America's largest builders of trolley cars.

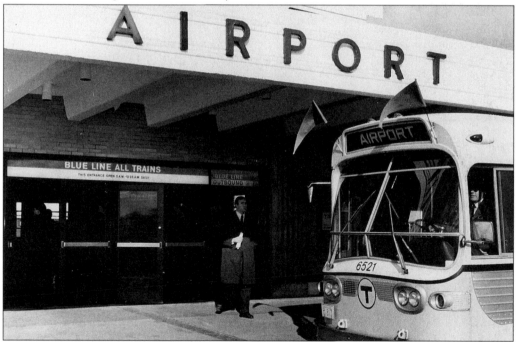

Boston's Logan International Airport is served by the MBTA's East Boston Blue Line from Airport Station, where shuttle buses pick up airline passengers for the short ride to the various airline terminals. East Boston, long a vital local transit center, is now the home of one of America's busiest airports.

Officers of the battleship *Missouri* leave buses chartered to bring them to a Red Sox-Detroit Tigers game at Fenway Park.

We would like to thank all of the enthusiastic readers of our first book,
Trolleys Under the Hub, for their continued interest and support.
The response to the first book was so overwhelming
that Boston in Motion seemed a natural continuation.
We also wish to thank Kevin Farrell and David Rooney.